KU-183-208

How to make FELT

Anne Belgrave

Search Press

Search Press Limited
Wellwood, North Farm Road,
Tunbridge Wells, Kent TN2 3DR

Reprinted 2000, 2001, 2003

Copyright © Search Press Ltd. 1995, 2001

Photographs by Search Press Studios, copyright © Search Press Ltd.
1995, except those on pages 8, 9 and 13 (bottom), which are by Mary
Burkett, those on pages 10 (bottom) and 11, which are by Stephanie
Bunn, and those on pages 7, 24, 76 and 77, which are by the author.

The publishers would like to thank Mr. Desmond Powell, of Bury
Cooper Whitehead Ltd., Royal George Mills, Greenfield, Oldham,
Lancashire, for his technical assistance and for the supply of the
photographs of feltmaking machines shown on pages 14 and 15. (The
black and white photographs are reproduced from *Precision Cut Felt
Parts Manual*, published in 1945 by The Felters Company, Boston,
Massachusetts, USA.)

The author would like to thank Richard Harris for the loan of the
nomad's bag shown on page 12 and the new kepenec shown on page
13 (top).

All rights reserved. No part of this book, text, photographs or
illustrations, may be reproduced or transmitted in any form or by
any means by print, photoprint, microfilm, microfiche, photocopier,
or in any way known or as yet unknown, or stored in a retrieval
system, without written permission obtained beforehand from Search
Press.

If you have difficulty in obtaining any of the materials or
equipment mentioned in this book, please write for further
information to the Publishers: Search Press Limited,
Wellwood, North Farm Road, Tunbridge Wells, Kent TN2
3DR, England.

For further information contact the International Feltmakers
Association at the following address.
The International Feltmakers Association
149, Manchester Road
Greenfield
Oldham
England OL3 7HJ.

ISBN 0 85532 795 2

Printed in Spain by A. G. Elkar S. Coop. 48180 Loiu (Bizkaia)

COLEG LLANDRILLO COLLEGE
LIBRARY RESOURCE CENTRE
CANOLFAN ADNODDAU LLYFRGELL

7 DAY LOAN 2/04

075740 746 BEL

075740

8.69
DM 2/04
Qw

How to make
FELT

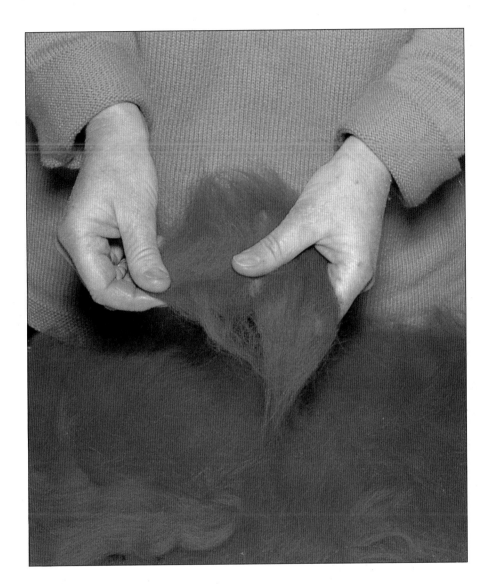

With thanks to members of the
International Feltmakers Association, who
have been generous with their time and
knowledge.

Contents

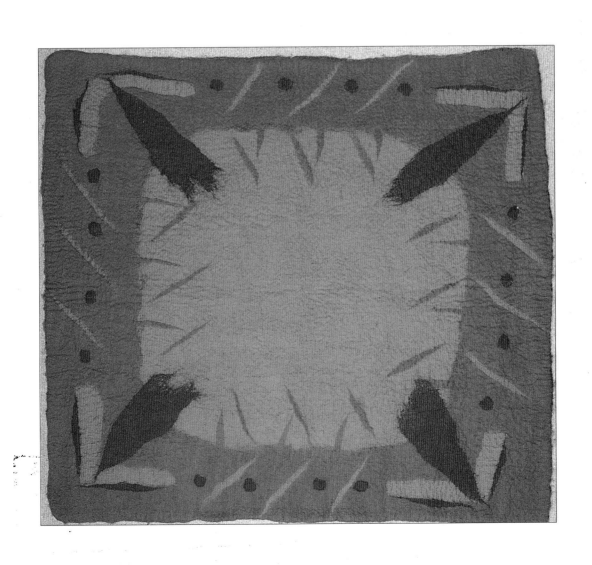

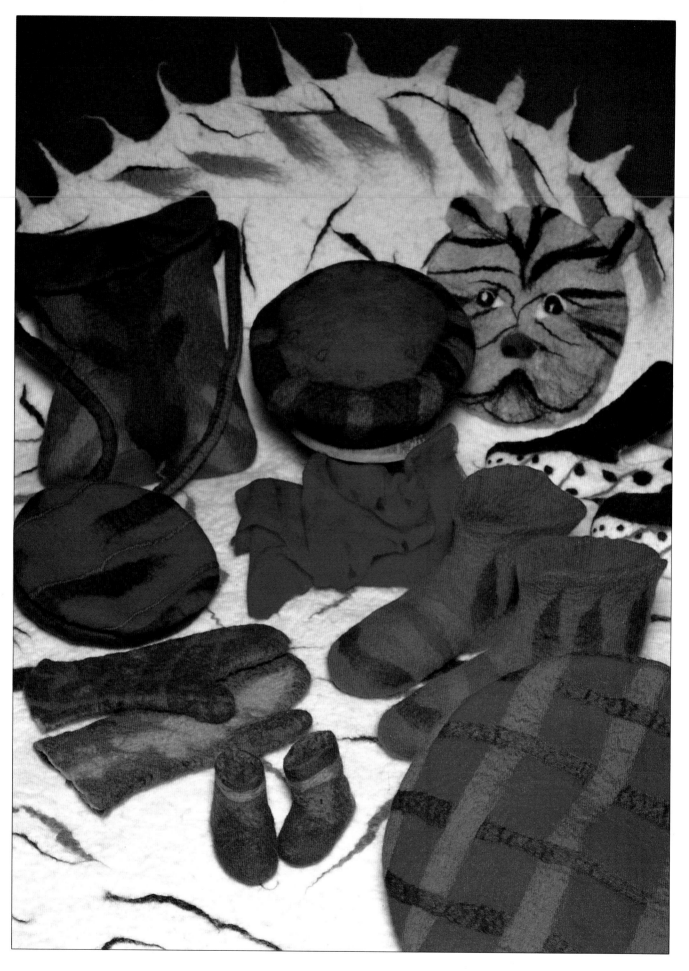

Introduction

Felt is made from wool. Cream turns into butter, dough into bread and wool into felt: these things just happen with the help of our hands. Add moisture and heat to wool, as well as pressure, and the fibres tighten, contracting into a dense mat.

You have probably experienced this for yourself by putting a woollen jumper in a hot wash and finding it has shrunk to a shadow of its former self. There is a story about how felt was discovered. A pilgrim was travelling in Ireland, a long weary walk with his feet sore and blistered; to ease the pain he gathered a handful of sheep's wool caught on a bramble bush and packed it inside his sandals. When he arrived later that evening he removed the wool and found it had felted; friction, heat and sweat had matted the fibres together. Anyone can try this out – it is the simplest form of felt.

Making felt will probably be a novel experience for most people, but it is a quick and easy method of creating cloth . . . far simpler than spinning and weaving, and it is amazing to be able to make something so tough from something so insubstantial.

I have a particular interest in moulded felt: shaping wet wool around a wooden block – or hand, foot or head – into strong three-dimensional forms, some of which you can see on the opposite page. The techniques in this book reflect my partiality for structural felt; but there are alternative methods for those who prefer to use needle and thread.

Right
Children find feltmaking great fun – this sample was made by one of my young students with the minimum of supervision.

Opposite
A selection of some of the items that are demonstrated in this book.

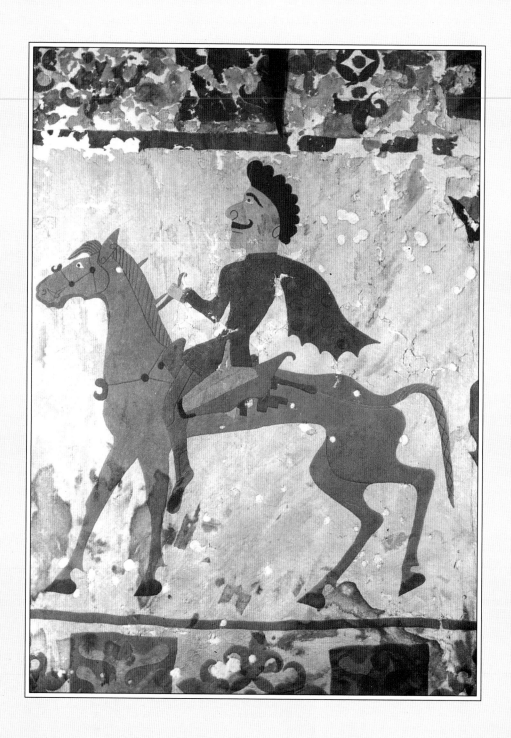

MARY BURKETT

COLEG LLANDRILLO COLLEGE
LIBRARY RESOURCE CENTRE
CANOLFAN ADNODDAU LLYFRGELL

Feltmaking through the ages

Feltmaking has a long history. The earliest archaeological evidence suggests that people were making felt in Central Asia during the Neolithic period. The most wonderful examples were discovered in burial chambers in the Altai Mountains of Siberia. Dating from 600BC and miraculously preserved by the permafrost, there are examples of rugs, wall hangings and other objects which show that felting skills were already highly sophisticated.

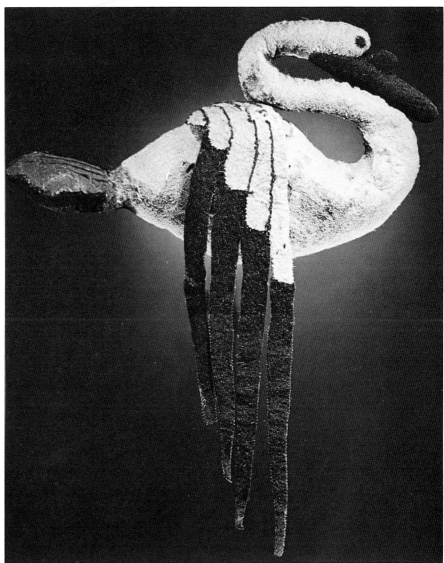

Opposite
'The horseman', a detail from the Pazyryk felt, excavated from a tomb in Siberia.

Right
'The swan', a three-dimensional felt from Pazyryk.

MARY BURKETT

9

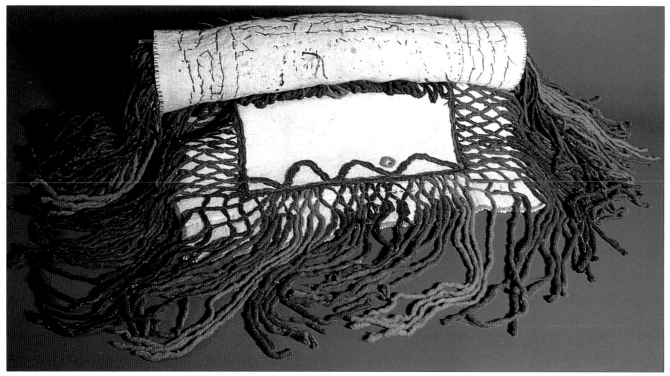

Felt horse cover from Uzbekistan, embroidered with felted woollen cord.

In the Turkman areas east of the Caspian Sea the different tribes produced knotted carpets which are now highly valued the world over for their richness of colour and design. These carpets were made in felt tents (called yurts or gers) and they were surrounded by other felt artefacts, felt being another element of the same tradition, though playing a more domestic role.

Kazakh felt yurt, at Merkyé, Kazakhstan.

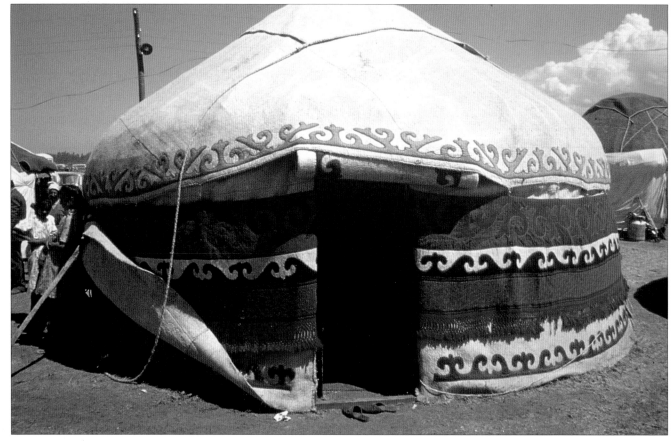

STEPHANIE BUNN

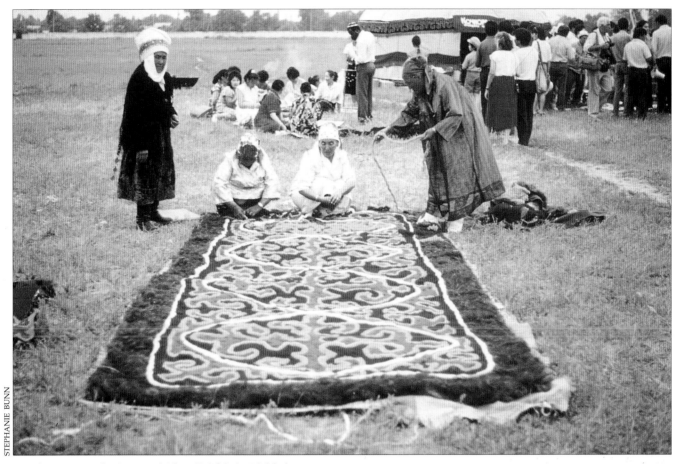

STEPHANIE BUNN

Kirghiz woman laying out 'Ala Kiiz' felt in Bishkak.

In some areas of the world feltmaking is still part of a thriving traditional culture; and it has been especially important for some nomadic tribes. When people travelled as a way of life, pasturing their flocks, they used felt for tent coverings, floor rugs, wall hangings and all kinds of carriers and bags; also, of course, as clothing. Divergent traditions of colour, design and method have evolved in the various ethnic groups, all based on an abundant supply of wool.

STEPHANIE BUNN

Detail from Kirghiz felt 'Shyrdak'.
Feltmaker: Kenjé Toktosoonova.

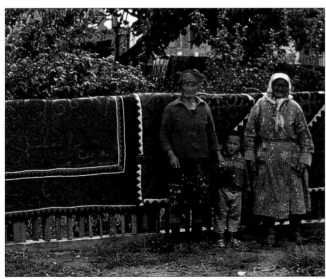

STEPHANIE BUNN

Kirghiz 'Shyrdak' felts airing, Tam Chi village, Kirghizia.
Feltmakers: Iraliev family.

11

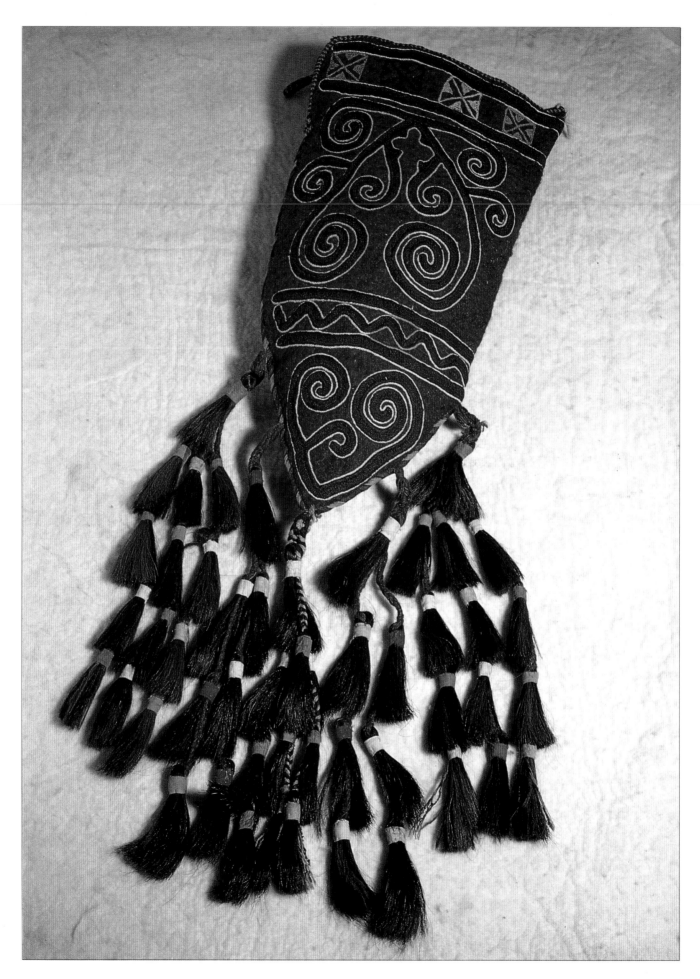

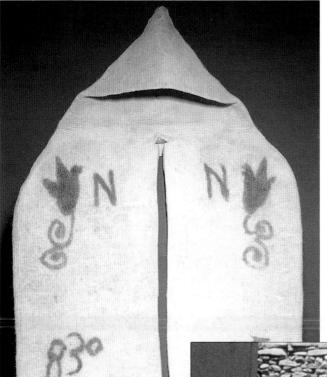

Felt still has a very important part to play in modern times: policemen in Russia wear felt boots in winter; in eastern Turkey, kepeneks (shepherds' cloaks) are still made and worn in the traditional way; and the erstwhile nomads still live in their felt gers (albeit equipped with modern conveniences) on the outskirts of Ulan Bator in Mongolia.

Left.
A new kepenek, still uncut. From the collection of Richard Harris.

Below.
Old and new kepeneks.

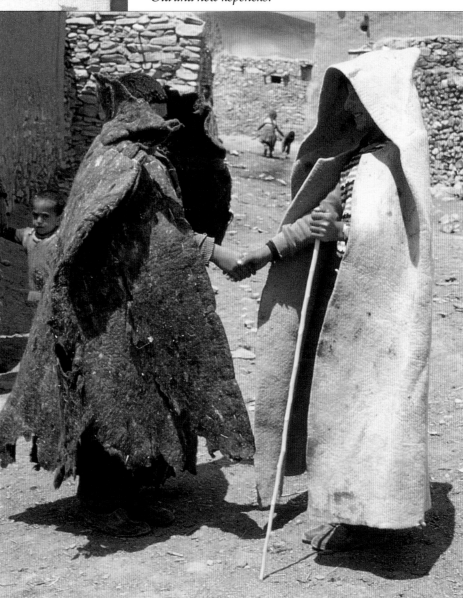

Opposite.
Nomad's bag from Uzbekistan, decorated with horsehair tassels. From the collection of Richard Harris.

MARY BURKETT

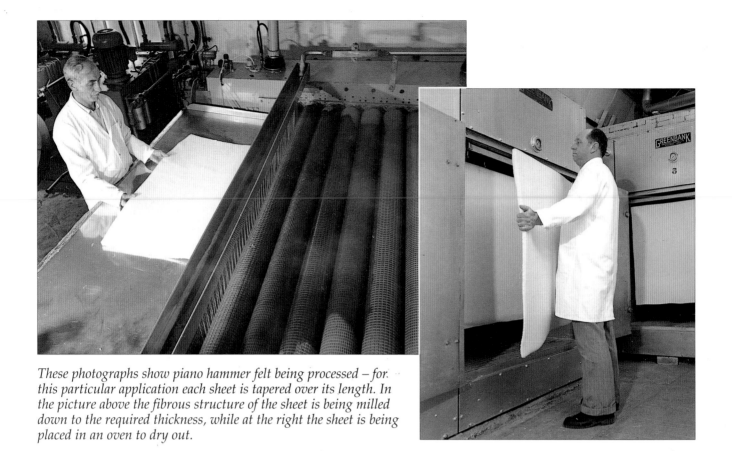

These photographs show piano hammer felt being processed – for this particular application each sheet is tapered over its length. In the picture above the fibrous structure of the sheet is being milled down to the required thickness, while at the right the sheet is being placed in an oven to dry out.

Felt has a more hidden role in an industrialised society but its intrinsic properties of insulation, flexibility, filtration and shock absorption are put to good use in the engineering industry. More visibly, machine-made felt can be seen in tennis balls, piano hammers, billiard-table cloths, and in the ubiquitous felt-tip pen. New developments in the field of geotextiles include enormous woollen booms used to mop up oil spills, and agricultural mulches. The mulches are used as the ecological alternative to black polythene because the woollen felt is bio-degradable and enriches the soil as it breaks down.

Feltmaking machines are usually custom-built to manufacture specific end products. However, the basic principles are much the same as those used to make felt by hand, and on the opposite page are some pictures which compare a few of the hand-made methods with the equivalent mechanised processes.

First the raw fibres are blended together to a recipe that will give the required characteristics of the felt: these include softness/hardness, wear resistance, permeability and, of course, price. Wool is the basic raw material, although other vegetable and man-made fibres can be included to obtain special characteristics.

The blended fibres are then opened out on a carding machine and laid evenly on a conveyor to form a web (also referred to as a batt or blanket). Sometimes a multilayer web is formed, with the fibres of each layer running in different directions.

Heat and moisture (in the form of wet steam) is passed through the web to start the felting process. The individual fibres swell, causing small scales on their surface to open up. Next, the web is mechanically worked by a series of rollers. The pressure applied by the rollers to the web creates friction, which causes the individual fibres to move against each other and progressively interlock. The more the web is worked, the greater will be the shrinkage and hence the density of the finished felt. The fibres do not physically shrink in size – rather, they bend around each other, allowing the scales to catch and hold other fibres. The more dense the felt is, the harder it feels.

At this stage the characteristics of the felt can be modified by additional processing. Flame- and rot-resistance, dyeing, impregnation and moulding are a few of the processes that are used for specific applications.

Finally, the felt is dried. For some specialised applications it is dried under tension to retain the controlled width and thickness.

Comparison between hand- and machine-made felt processes

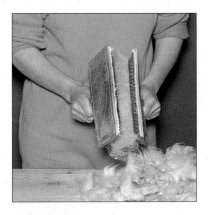

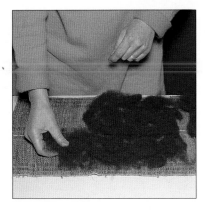

The first stages of feltmaking involve the laying down of a web of woollen fibres. Above left: raw fleece being carded by hand. Left: carded wool being teased out to form an even layer of fibres. Above right: raw fleece being picked (sorted). Right: a continuous web being drawn off on a carding machine.

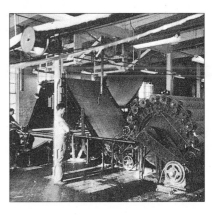

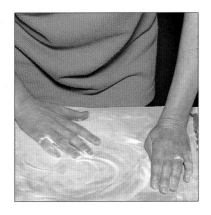

There are two distinct stages in making felt by hand: they are referred to as felting and shrinking. Felting (see left) is the initial addition of soap and water and hand pressure to make the fibres start to interlock, while shrinking (see right) is a rolling action which completes the felting stage. The two operations are usually combined on one machine which is normally referred to as a hardener (see below).

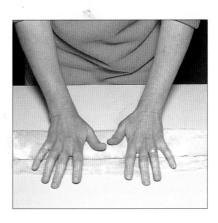

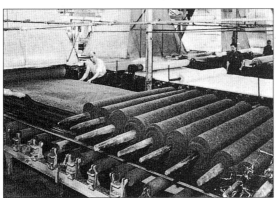

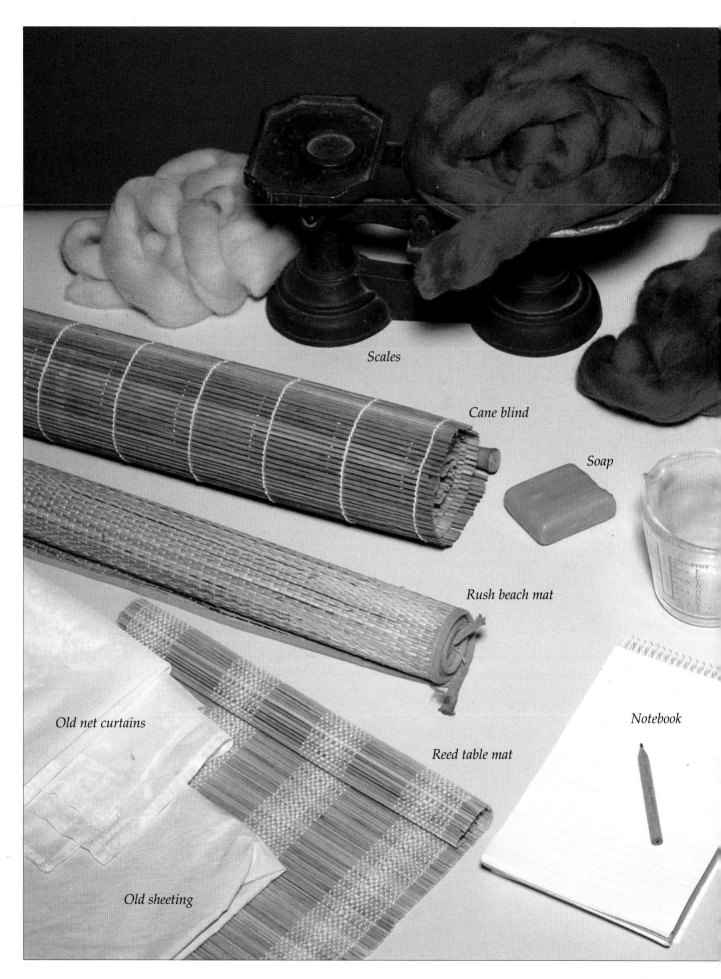

Scales

Cane blind

Soap

Rush beach mat

Old net curtains

Reed table mat

Notebook

Old sheeting

Equipment & materials

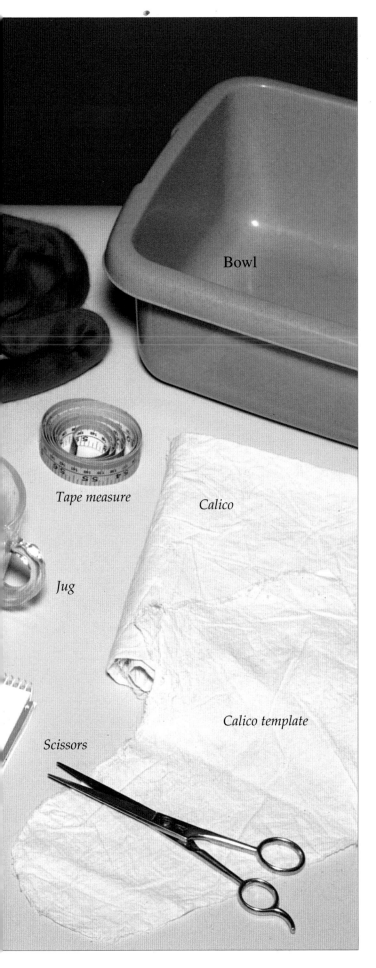

Bowl

Tape measure

Calico

Jug

Calico template

Scissors

You really do not need very much in the way of equipment to make felt. Below I have listed those items that I use in my studio; I have also added one or two items that can be helpful but are not essential. Apart from these, the only things that you may not have in your home are the reed mats. However, these are relatively inexpensive to buy and you can always use second-hand ones.

• *Flexible rush/reed mats or table mats for shrinking your felt. If you cannot find table mats, use beach mats, which are more readily available. Cut one in half and tie up the cut edges so it cannot unravel.*

• *Cane blinds for making rugs, blankets, wall hangings and other large pieces of felt.*

• *Old net curtains cut to various sizes – placed on top of the wool before felting commences.*

• *Calico – this is used for making the templates for hats, slippers, bags, etc. I find that calico has just the right thickness and flexibility for this purpose. A good material shop will stock it.*

• *Old sheeting cut to various sizes and used to roll up the felted piece prior to shrinking, to stop the roll from slipping around.*

• *Soap. I always use a cheap bar of soap, but you can use washing-up liquid or diluted soap-flakes.*

• *Scales for measuring wool.*

• *Tape measure.*

• *Jugs/bowls for water.*

• *Notebook.*

• *Hat blocks. These are very useful, but they are also expensive and not really essential (see page 59).*

• *Hand carders or a drum carder. Again these are not essential pieces of equipment, especially if you are going to buy only prepared fibres (see pages 22 and 23).*

The raw material

Sheep's wool is the basic raw material used for making felt. Sheep's wool can be bought in various states: as a raw fleece, carded wool, or combed tops – the latter two being ready for use and ideal for feltmaking.

It is obviously a short cut to buy processed wool, but it can be very satisfying to start from scratch and buy a raw fleece.

There are also a lot of other fibres which can be used for making felt but they can be difficult to obtain and may be rather expensive.

RAW FLEECE

You can obtain a raw fleece and prepare the wool yourself, but you must have access to the tools for carding it. I have included instructions for carding wool on pages 22 and 23. However, unless you really want to work with raw fleece I would suggest that you use the carded wool or combed tops.

CARDED WOOL

This is machine-processed fleece and is a mass of loose fibres. It is available in a range of natural colours.

COMBED TOPS

These are also machine-processed but the fibres lie parallel in a long soft rope. Combed tops are pre-dyed in a very wide range of colours.

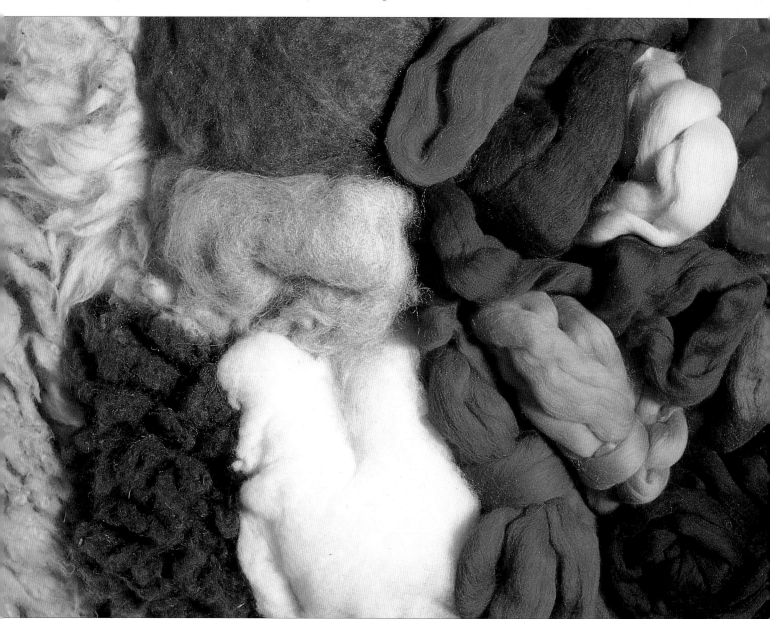

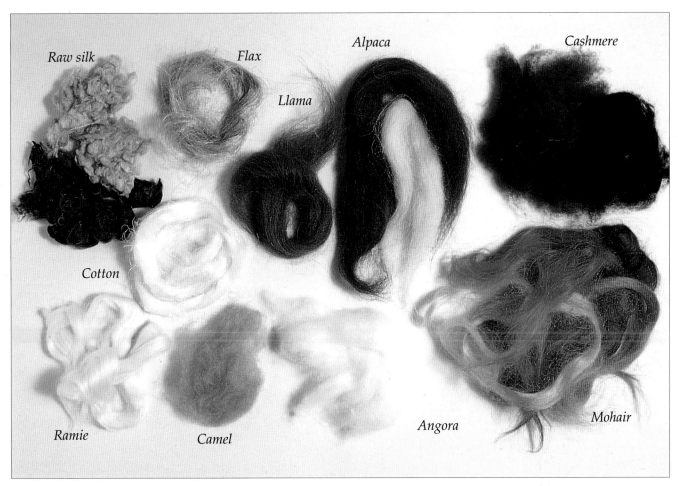

Raw silk

Flax

Alpaca

Cashmere

Llama

Cotton

Ramie

Camel

Angora

Mohair

A selection of some of the other fibres that can be used to make felt or incorporated with wool as a decoration.

OTHER FIBRES

Various types of animal wool and hair will felt: angora, mohair, camel, cashmere, llama, alpaca, the hair of some cats and dogs; and, of course, human hair, which felts into dreadlocks. It is also possible to use synthetic fibres, but only when they are mixed with wool, as they do not have the necessary cell structure to felt on their own.

Equally, other natural fibres such as cotton, ramie, silk and flax can all be used, though they too cannot felt alone.

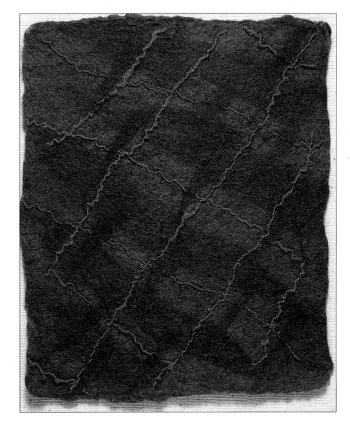

Right
This sample piece is decorated with lengths of spun wool.

Opposite
From the left: raw fleece, carded wool and combed tops.

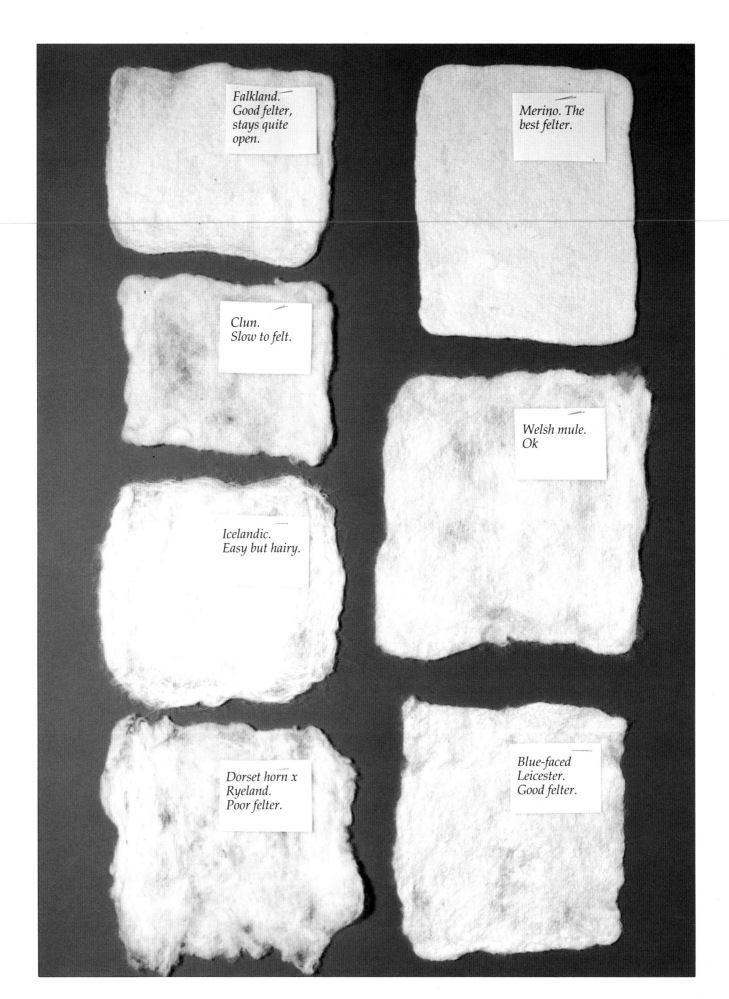

Types of wool

It is a simple fact that some wools felt better than others, and that different breeds of sheep have particular characteristics: their wool can be soft or rough, short or long, and make loose or compact felt. The technical explanation of why wool felts is based on the cell structure of individual fibres. By examining one of the fibres under a microscope you can see the outer covering of scales. It is this arrangement, and the inbuilt elasticity of the fibre due to the structure of the longitudinal cells, which enables wool to felt.

Your choice of wool depends upon what you want to make. If you are only going to hang something on the wall it need not be tightly felted. At the other extreme, however, the fibres of a floor rug must be compacted to give a strong, hard-wearing and impervious surface. When you are making hats a softer wool is usually appropriate; slippers can be coarser as they also receive hard wear. Another criterion is the amount of work involved, so I try to choose a wool which felts quickly and therefore easily. I most often use a British wool, Blue-faced Leicester, or merino, which comes from hotter, drier countries – New Zealand, Australia and South Africa; merino wool tends to felt on the sheep in Britain's damp climate.

Most wool will felt to some degree; if there is plenty of crimp (i.e. each individual fibre is very wavy), it is more likely to be useful, but really the best thing is to felt a good handful and see what happens. Then felt some merino wool by way of comparison. If you have sheep in the fields around you, pull some wool off the fences and make a sample; perhaps you can then buy a fleece and process it yourself.

The best British breeds, then, are blue-faced Leicester, Cheviot, Masham, the crosses called Welsh Mules, and merino crosses, which you can occasionally find. From other countries you can try merino, Polworth, Corriedale, Icelandic, Falkland and Gotland.

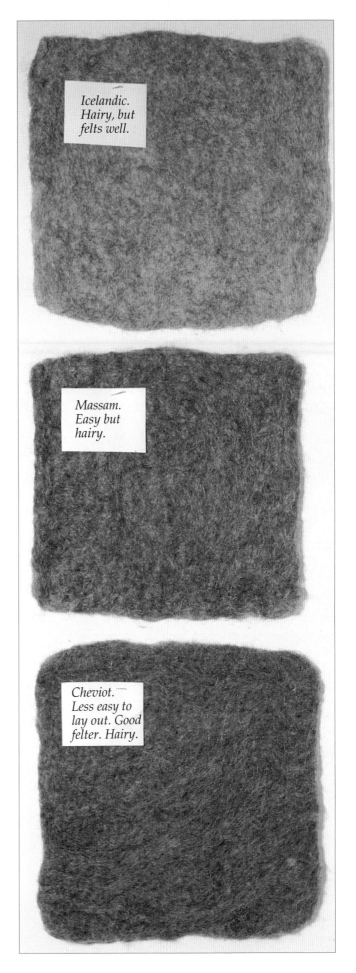

Icelandic. Hairy, but felts well.

Massam. Easy but hairy.

Cheviot. Less easy to lay out. Good felter. Hairy.

Opposite and right
Some of my collection of felted samples.

Preparing a fleece

Before handling a raw fleece you should be aware that it comes from a live animal and can be rather dirty. More importantly, remember that farmers use toxic chemicals as sheep dips – so wear rubber gloves and work outside (or at least away from food-handling areas). Try to buy fleece from an organic farmer or one who does not use organo-phosphorous dips.

It is not absolutely necessary to wash the wool before use; it rather depends on the state of the fleece. It may be enough just to card it, as a lot of bits and pieces simply fall out during that process.

If you want to dye the wool you must wash it first. Use warm soapy water and treat it gently or it will become very tangled and even start to felt. Rinse several times then put it in an old pillowcase and spin dry it. Alternatively, you could hang it on a line or spread it out in the sun.

Carders are two rectangular pieces of wood fitted with short handles. The flat surface of each carder is covered with a layer of steel wire pins or 'teeth' which are used against each other to card the wool. The knack of hand carding is to work slowly and thoroughly; use only small tufts of wool and work the carders lightly so that the teeth hardly brush together as they comb through the fibres.

A drum carder is a machine that has two rollers each covered with a similar set of teeth to those on the hand carders. Different models vary slightly but they all have much the same sort of adjustment to engage and disengage the two rollers.

HAND CARDING

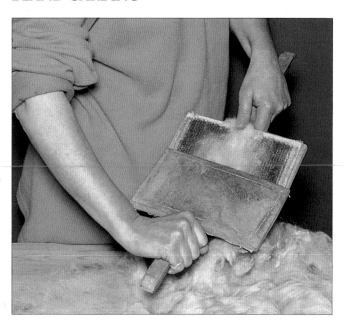

1. Place a small tuft of wool on the pins of one of the carders up near the handle. Hold this carder in one hand with the teeth uppermost. Take the other carder in your other hand (with the teeth pointing down-wards) and then, combing away from you, gradually transfer all the wool on to the second carder.

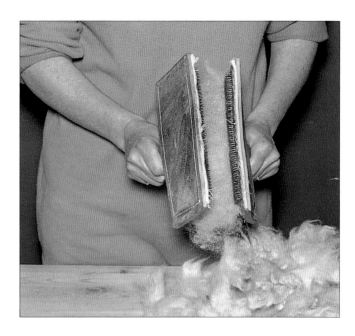

2. Pass the wool back from one carder to the other by combing in the opposite direction with short strokes to disengage the fibres. Repeat the process several times until the wool is sufficiently combed and clean, then remove it in one piece.

DRUM CARDING

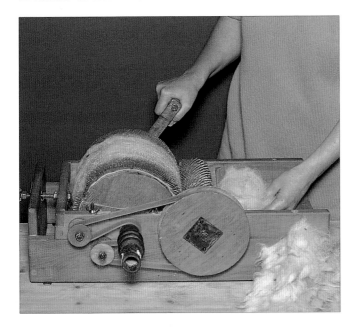

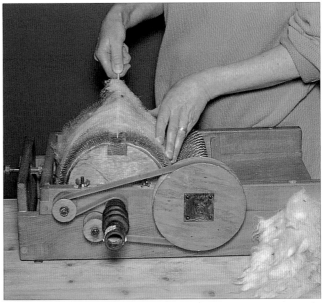

1. Set the position of the rollers so that the teeth only just engage and then feed a little wool into the base of the small roller. Turn the handle so that the fibres are combed between the wire teeth and pass on to the big roller. Gradually feed in more wool, spreading it evenly across the roller until the drum is well covered.

2. When the large roller is full, disengage the rollers and turn the handle until the groove in the large roller is on top. Place a knitting needle or your finger (remember that the teeth are sharp) in the groove, under the wool, and work your way across the groove, easing the wool apart.

3. When the wool is completely free, slowly turn the handle and pull the 'batt' off in one piece.

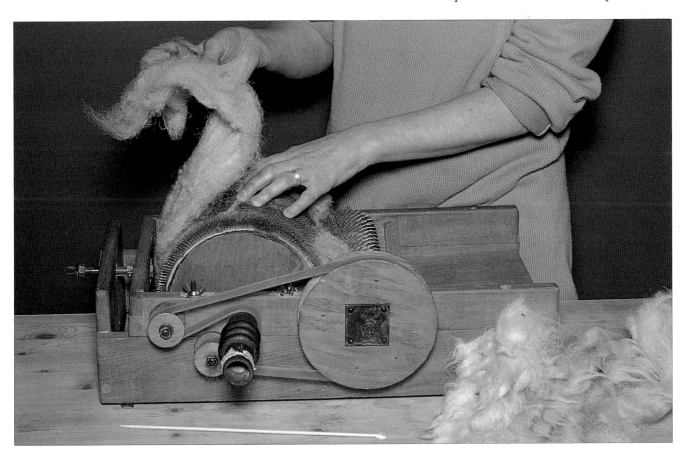

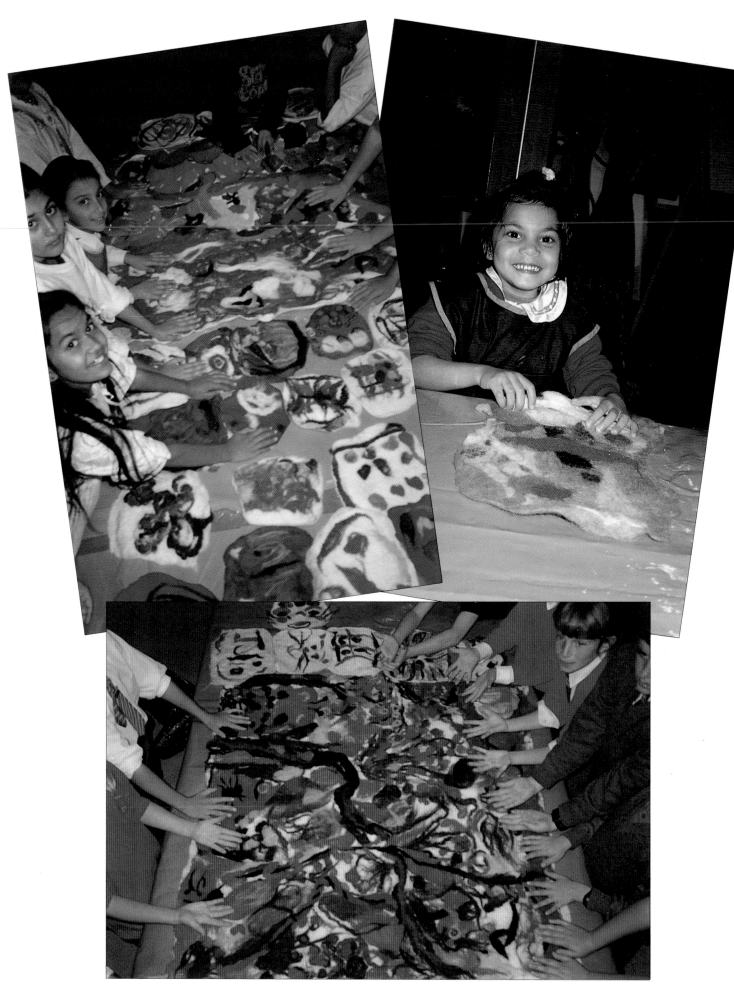

Basic techniques

In this chapter I will show you how to make small flat sample pieces of patterned felt with both carded wool and combed tops. These basic processes are used for making all the projects described later in the book. There are no hard-and-fast rules for making felt – different people use different methods – and you can adapt my ways to your own liking.

The samples all start off as rectangles that measure roughly 30 x 50cm (12 x 18in), and it is worth keeping notes of these sizes so that you can compare the finished sizes and see how different wools shrink.

You will need about 15g (½oz) of one colour of prepared wool (carded or combed) plus a few bits of other colours for decoration.

Gather your tools: a small rush mat; a piece of net curtain, slightly bigger than the mat; a slightly bigger piece of old sheeting; your soap; and about 150ml (¼pint) hot water (always use water that is as hot as you can handle because it speeds things up).

You can work on the kitchen table, a work surface or a draining board; there is no need to use a lot of water or to make too much mess. Avoid using too much soap to start with, as it will interfere with the initial felting process: you need just enough to give a nice slippery surface which is easy to rub.

One of the project samples made in this chapter – before and after felting and shrinking.

Feltmaking is a wonderful craft for children – either making small individual sample pieces, or working together on a large wall hanging.

Laying out

The first stage is to lay out the wool on the rush mat in three separate layers. I use different methods of laying out wool – one for both hand- and machine-carded wool and two for combed tops. On the following pages I make three samples using each of the methods. Whichever way you use, lay the pieces of wool so that they just touch and do not overlap too much; in this way you get an even thickness across each layer.

You do not need to worry about the direction of the fibres when laying out **carded wool** as they are already well mixed up in the carding process. However, you will have to tease out each chunk into a uniform density.

The fibres in **combed tops** are all parallel to each other and you will have to arrange the layers so that the fibres run at 90° to each other in alternate layers. This arrangement ensures that your felt has the necessary strength. There are two ways of making each layer; the first method uses 15cm (6in) lengths of fibres while the second method uses short tufts. Both work well – the choice is yours, but I find it quicker to work with the latter method.

1. Pull off a chunk of wool and tease it out evenly: you can do this by holding the wool up in front of you or by laying it down flat on the mat. You want to end up with a piece about 15cm (6in) square.

2. You can see how evenly you are teasing it out by holding the piece over a light-coloured surface or up against the light.

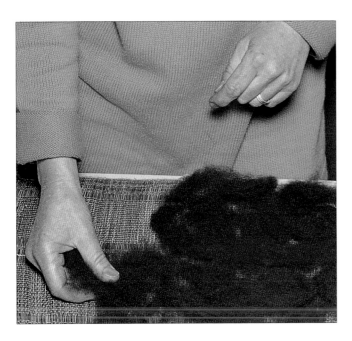

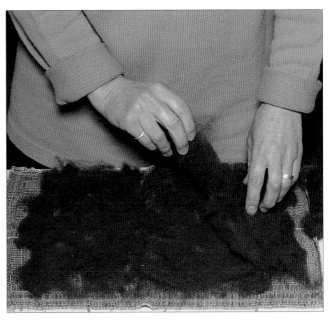

3. Lay down the teased-out pieces of wool next to each other to form the first layer.

4. Lay down a second layer over the first one. With carded wool it can be difficult to count the layers, so work across the mat in a uniform fashion to help you keep track of where you are.

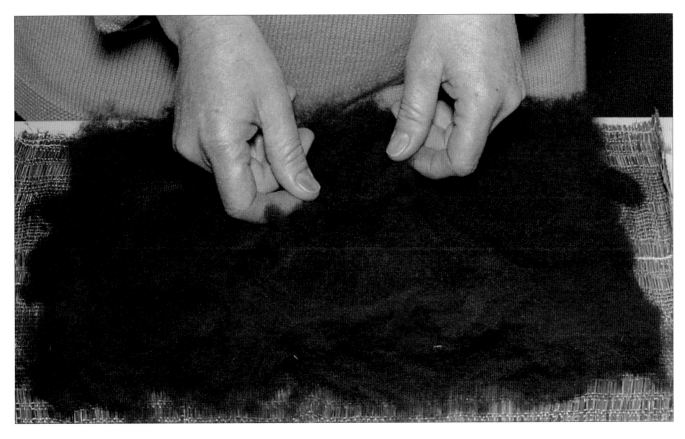

5. Finally, make a third layer over the second to complete this initial part of the process. You can now add some decoration on to the sample and move on to the felting stage (see page 31).

LAYING OUT LONG LENGTHS OF COMBED TOPS

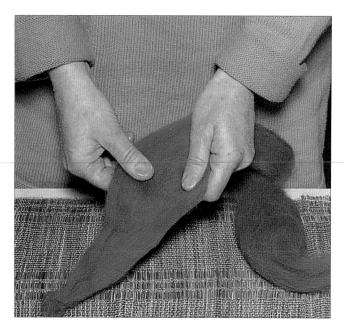

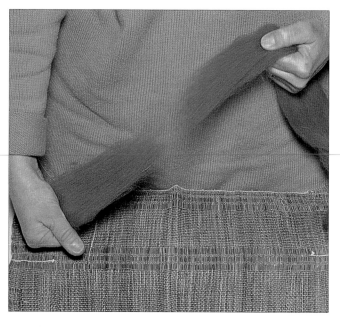

1. Take a hank of your chosen combed top and open out the fibres about 15cm (6in) from the end.

2. Hold the hank in one hand, about 20cm (8in) from the end, and then use the other hand to pull off a 15cm (6in) piece.

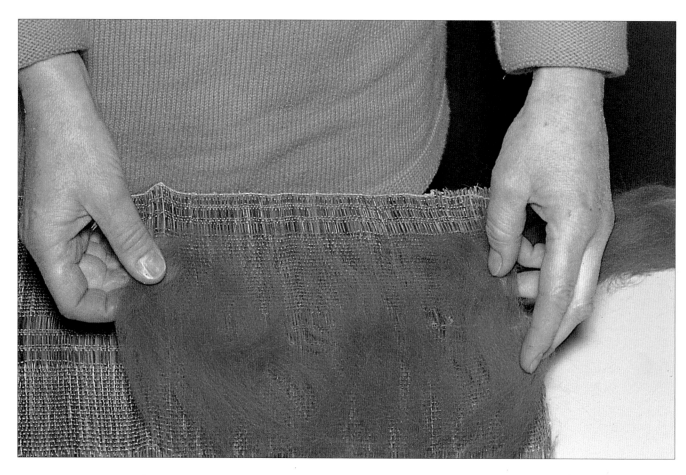

3. Tease it out evenly, checking the distribution of fibres, and lay this piece down on the mat.

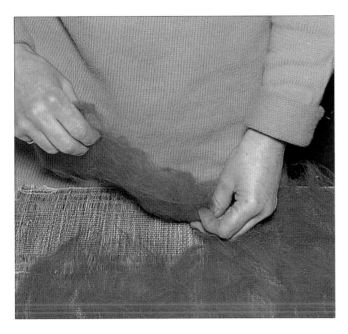 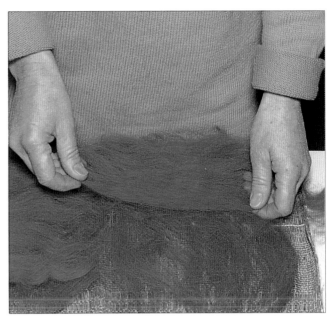

4. Pull off further pieces and lay them down next to each other with all the fibres running in the same direction until you have completed your first layer.

5. Now build up a second layer in a similar way, but this time lay the pieces so that the fibres are at 90° to those in the first layer.

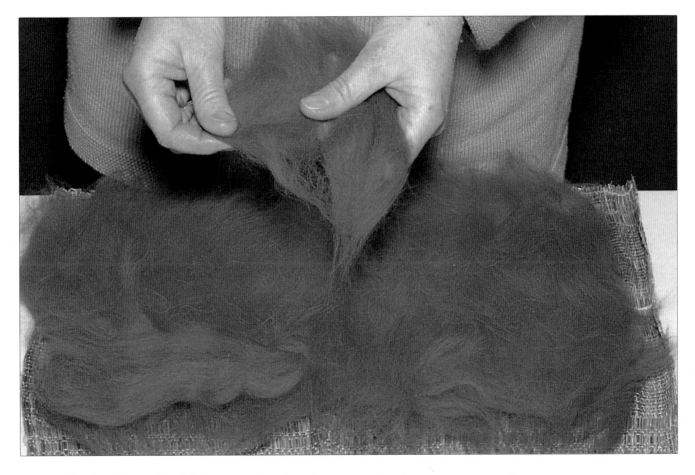

6. Finally, lay down the third layer with the fibres running the same way as the first. You can now move on to the decorating and felting stages (see page 31).

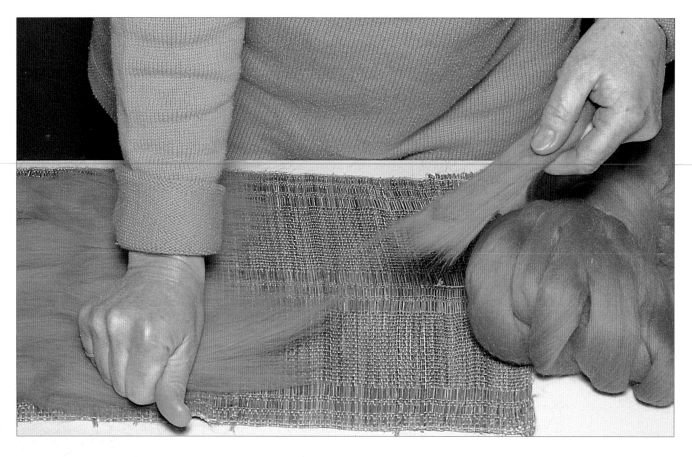

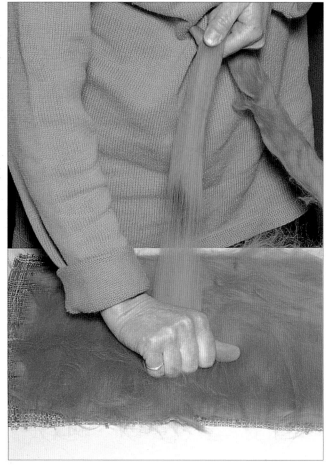

1. Tease out the end of a hank of wool, and then, holding the wool in one hand about 10cm (4in) from the end, pull off a tuft with the other hand and lay the wool on the mat. Pull off more tufts and lay each just next to the other (like roof tiles), with all the fibres running in the same direction, slowly building up the first layer.

2. Work a second layer in a similar way but this time lay the tufts so that the fibres are at 90° to those in the first layer.

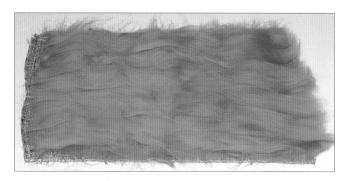

3. Finally, make the third layer with the fibres running in the same direction as the first.

Decorating the samples

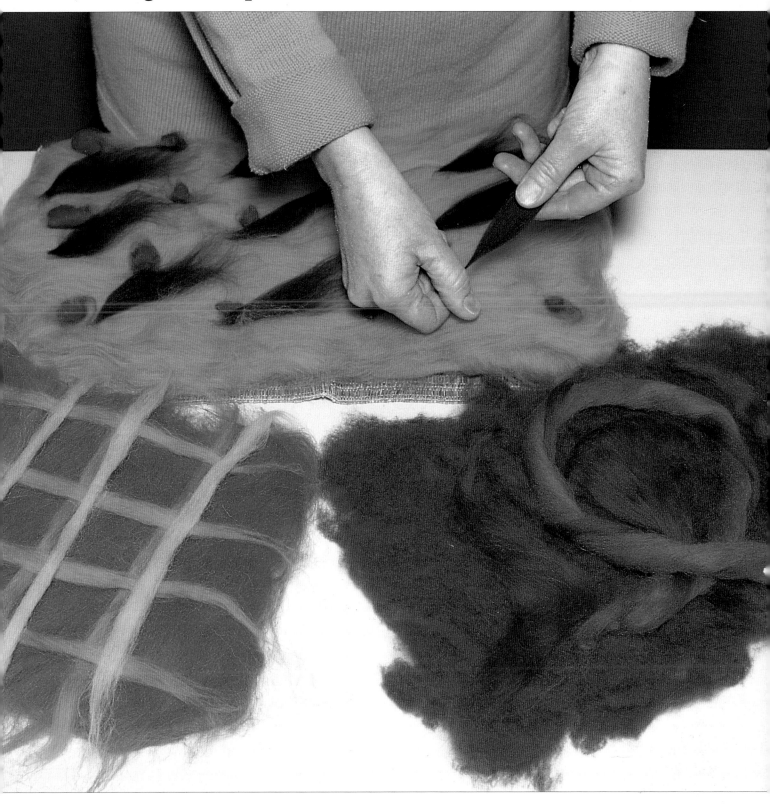

I have now laid out three samples, each consisting of three layers of one colour. These can now be decorated before the actual felting stage.

Pull out small tufts of different coloured wool and simply lay them on top of the third layer in some form of design. You can also make lines, dots or even large areas of colour, or tease out wisps of different colours and layer them. There are endless possibilities of colour and design. In the picture I am decorating the third sample: the other two samples are shown in the foreground.

Felting

The next stage is to use soap, water and friction to start the felting process. In this example I am felting the third sample.

1. Cover the sample with the piece of net.

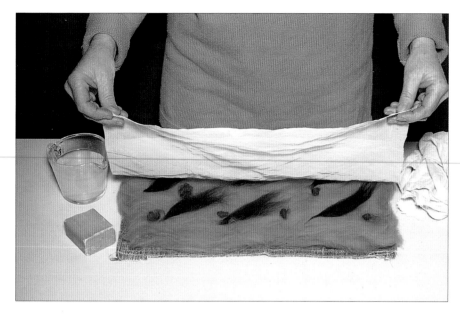

2. Pour a little hot water on to the net in the middle of the sample.

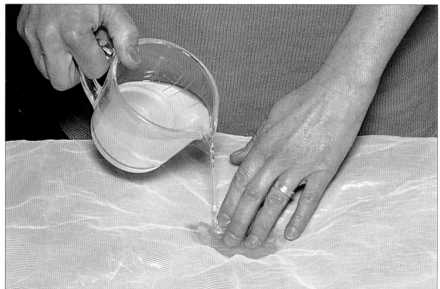

3. Hold the net in place with one hand. Hold the bar of soap in the other hand and gently rub it over the wetted area, working out from the middle.

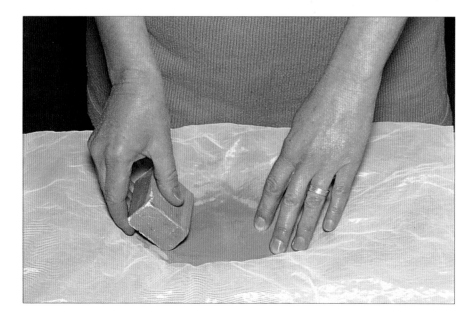

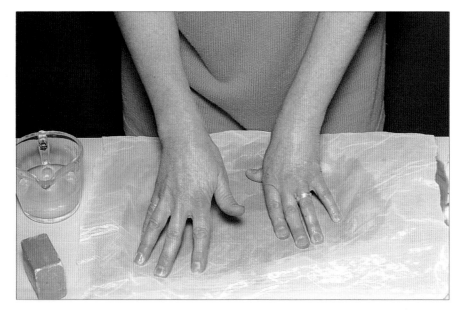

4. Apply more water and soap on the dry edges and then work with the fingertips of both hands until the whole piece is wetted and flat. Be gentle at this stage and try not to move your design around too much.

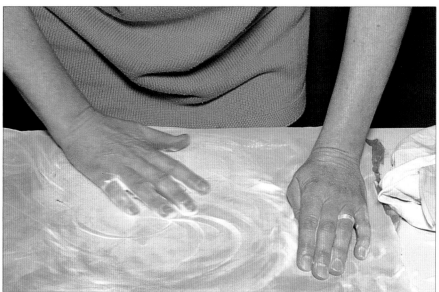

5. Now rub more vigorously, using a polishing action with the palm of your hand all over the piece. Start rubbing gently and gradually increase the pressure. This stage of the process may take up to ten minutes, depending upon you and upon the type of wool.

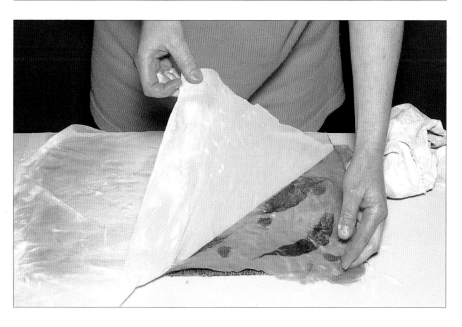

6. Gently peel the net off the sample, taking care not to pull any wool away with it. If some of the design does lift off, replace the net and rub a little longer, using more hot water and more soap.

7. If you have rubbed really hard, some of the wool fibres may have travelled up on to the surface of the net. Do not worry; just use your palm and fingers to hold down the sample as you peel off the net and break away the fibres.

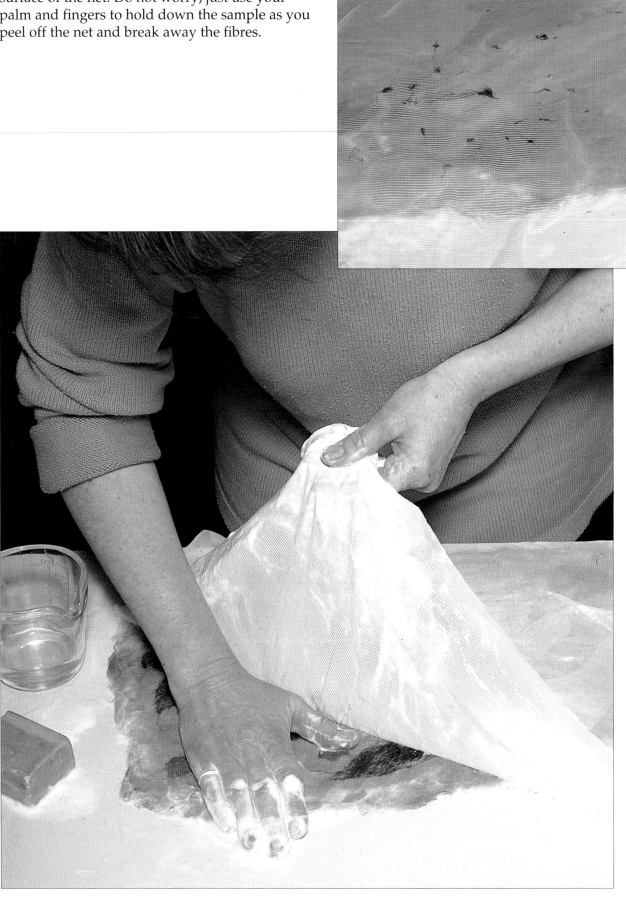

Shrinking

This is the final part of the process and involves the use of friction
by rolling the sample wrapped up within the rush mat.

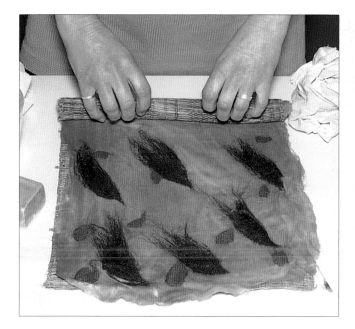

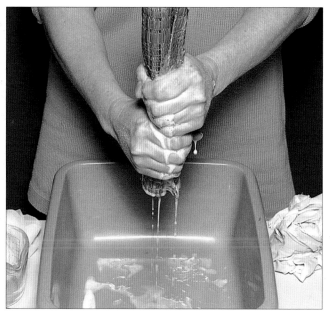

1. Make a loose roll of the mat with the felt inside.

2. Hold the roll upright and gently squeeze out the excess water (do not wring it out) into a bowl or sink. Mop up any excess moisture from the work surface.

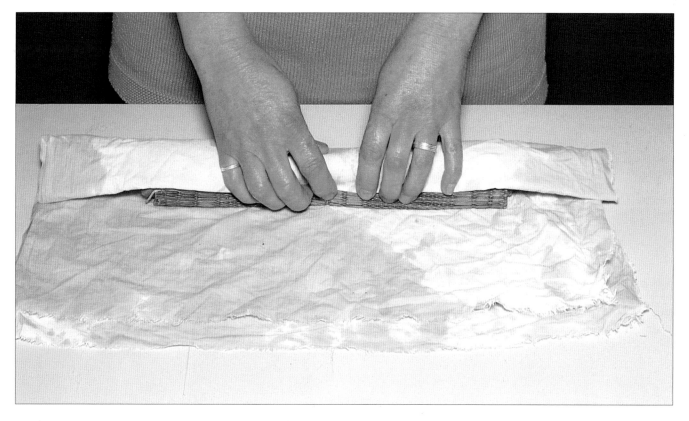

3. Lay a piece of old sheeting on the work surface and wrap it around the
rolled mat: during the next stage the sheet will prevent any slippage.

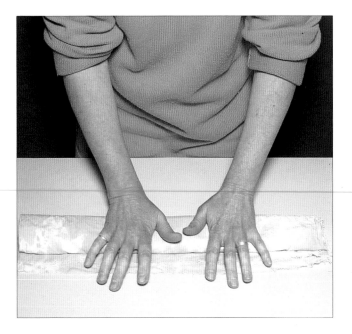

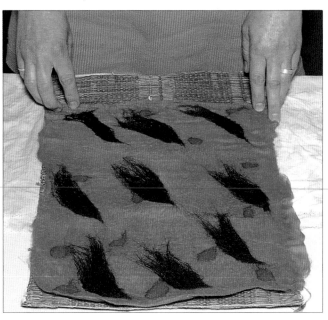

4. Now use the palms of your hands to roll the mat to and fro for a minute or two, gradually increasing the pressure. Pressure and movement combine to create the friction that helps to shrink the felt in the direction in which it is rolled.

5. When you unwrap the sample you will note how the pattern has shrunk, particularly on the end that was in the middle of the roll.

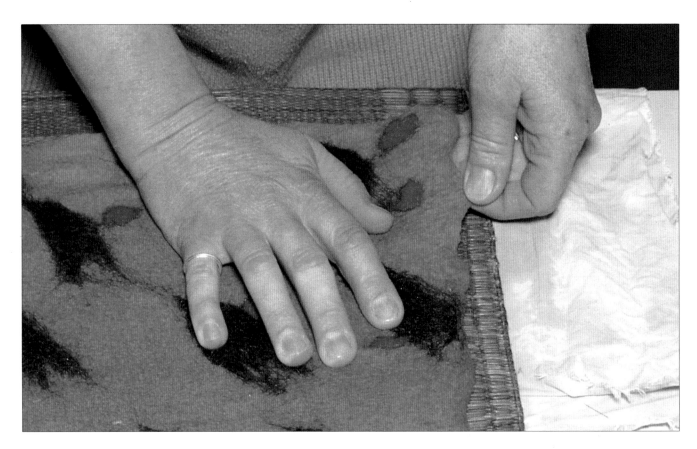

6. Gently tug the edges of the sample to straighten them up: the wool is very flexible at this stage and you will find you can easily change its shape.

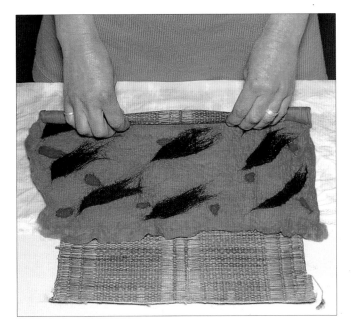
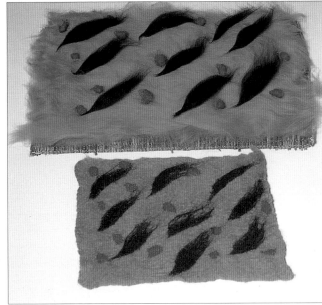

7. Turn the sample through 90° and wrap it up again; first in the mat and then in the sheeting. Continue rolling and turning to each edge, maybe twice around, making the roll tighter each time and using more pressure. How long you continue the rolling process depends partly on your stamina, what the felt will be used for and whether you want to see how small it can go.

8. This is only a sample, so you only really need to observe how the felt strengthens and hardens as it shrinks. When you are happy with the result, rinse out the soapy water under the cold tap, squeeze and leave the sample to dry. Compare the size of the finished piece to its original measurement.

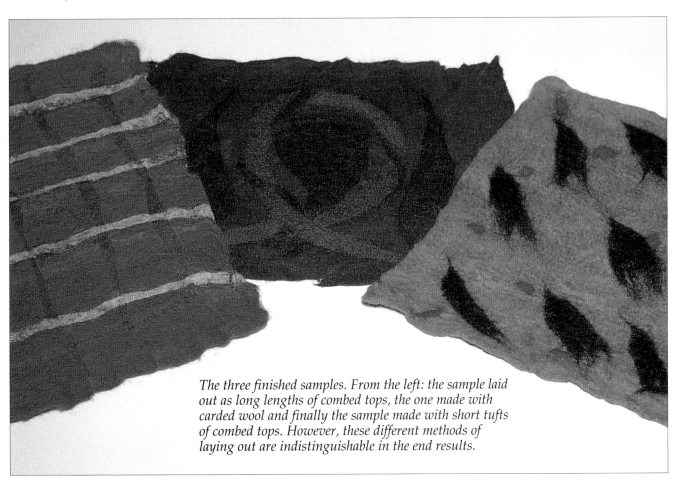

The three finished samples. From the left: the sample laid out as long lengths of combed tops, the one made with carded wool and finally the sample made with short tufts of combed tops. However, these different methods of laying out are indistinguishable in the end results.

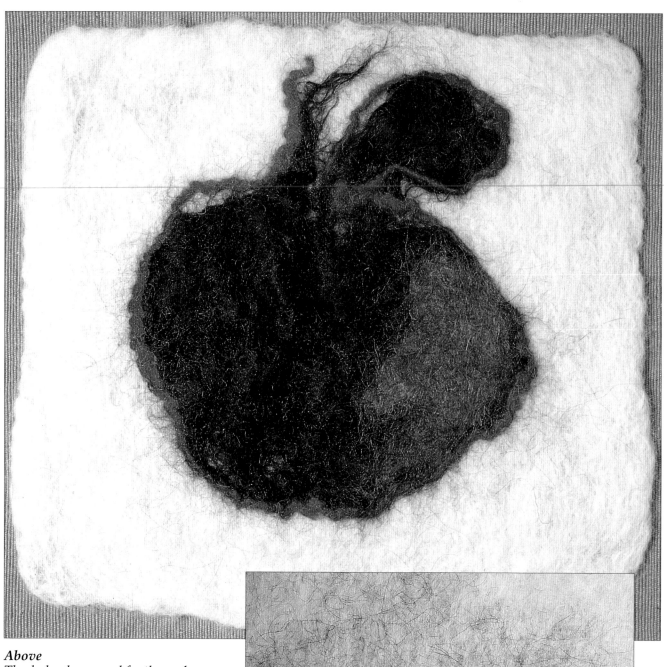

Above
The dark colours used for the apple design of this piece were laid out on a white background.

Right
The enlarged detail of the above design, photographed from the reverse side, clearly shows how the dark fibres travel through the light ones during the felting and shrinking processes.

Other techniques

When you have produced the samples shown in the previous chapter, I would suggest that you make some other samples, experimenting with different thicknesses of wool, different shrinkage rates and different types of fibre. Do keep notes of your results for future reference.

Use a dark top layer over white and observe how the fibres pass through each other to the surface. Try using some lengths of spun wool and other fibres to decorate your samples. Make a larger sample using a beach mat, maybe using more layers.

Apart from decorating the surface of your felt at the laying-out stage you can also use other techniques: inlay, mosaic and sewing. On these pages are a few of the basic methods associated with these techniques which will enable you to work out your own further variations.

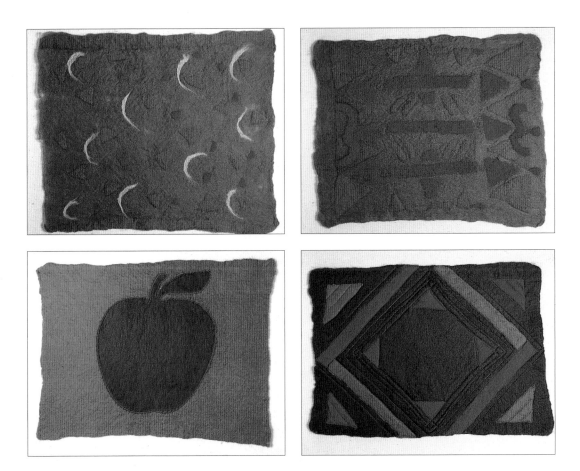

Samples using different techniques. Top left: inlay using loose fibres and pre-felted sheet.
Top right: inlaying with pre-felted sheets. Bottom left: Mosaic with cord sewn on to the joins.
Bottom right: Quilted felt layers.

Inlaying

With this method of decoration it is possible to create designs that have relatively hard edges, rather than the soft ones of the earlier samples.

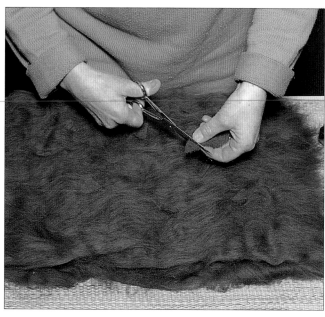

1. Make two pieces of plain felt with different colours of wool (I have used some blue and tan), following the stages of laying out and felting that are shown on pages 26 to 34. Felt them just enough to ensure that the fibres are beginning to come together. For this exercise I am going to use these, together with a little contrasting combed top, to decorate another three-layer base of unfelted grey-coloured combed top.

2. Make a three-layer bed using the grey combed top and then cut out small triangular shapes from the pre-felted blue sheet. Drop them randomly over the bed of grey.

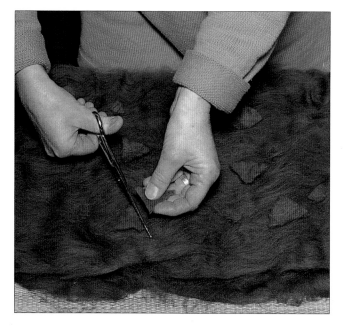

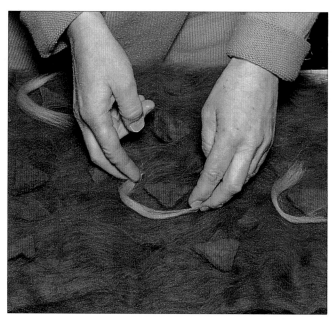

3. Now cut out some larger shapes from the sheet of tan-coloured felt.

4. Pull off some wisps of yellow combed top and arrange these in moon shapes over the sample.

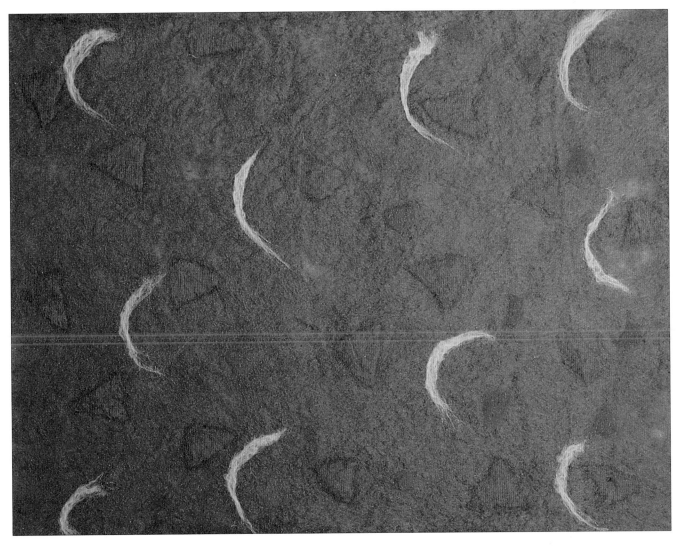

5. Carry out the felting and shrinking stages as shown on pages 32 to 37 until the pieces are felted together. Wash, rinse and dry to finish the piece.

6. An alternative method is to pre-felt three different coloured sheets and then cut out pieces from two of them to decorate the third. Again follow the felting and shrinking stages given on pages 32 to 37. With this method it is important to ensure that the bits of the design do not move around under the net during the early stages of felting.

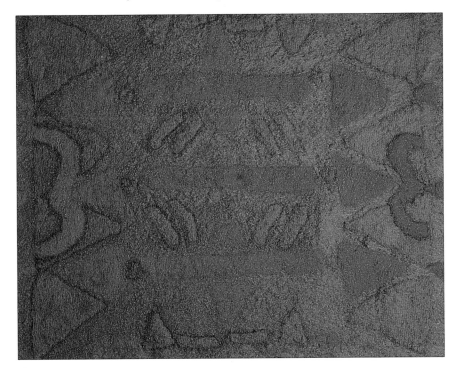

Mosaic

This technique involves combining a negative and positive image of the same design and it can be worked in two ways.

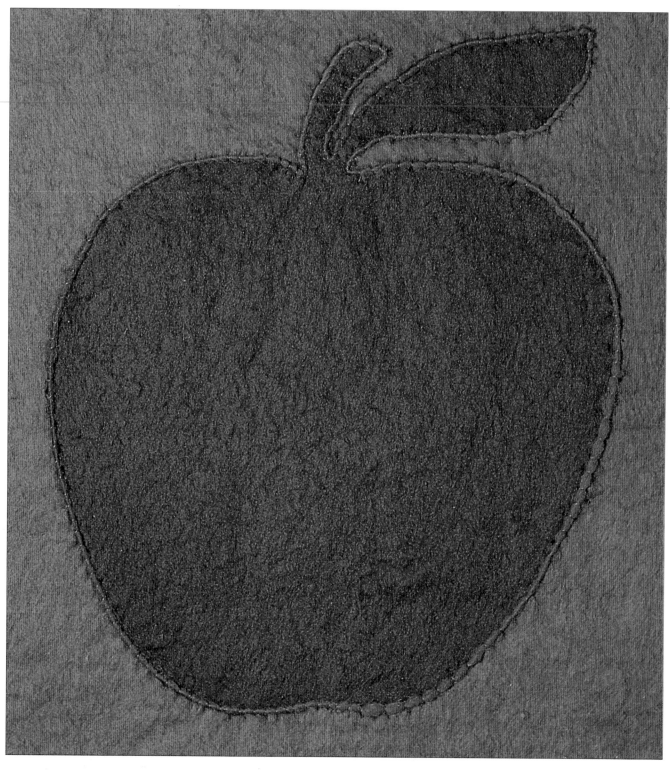

1. Make two plain sheets of felt, working through all the stages of laying out, felting and shrinking, but omitting any decoration. Rinse them out and dry them. Now, using a template, cut out the same design from each piece and then place the positive image inside the negative one, and vice versa. Sew the two pieces together around a cord of contrasting coloured wool to line the join. This method is a traditional technique still in use in Central Asia.

2. Pre-felt two sheets of wool in contrasting colours and cut out the same image from each. Lay the positive image taken from one sheet inside the contrasting negative image from the other and lay them in position on a bed of either another pre-felted piece or on a bed of raw wool. Continue the rest of the process as described above.

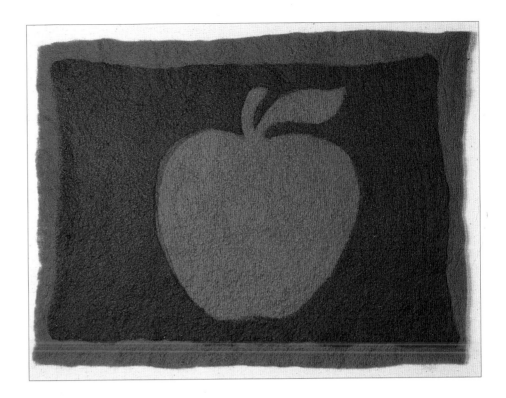

Sewing

You can also sew the felted designs on to a felt background, or sew into the surface of the felt using quilting and embroidery techniques.

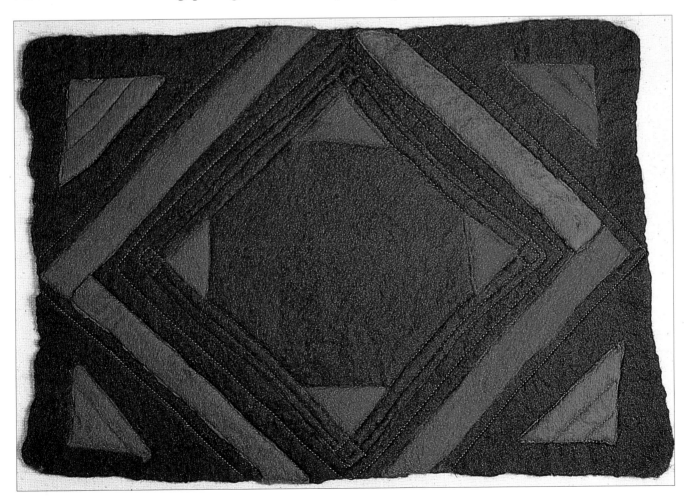

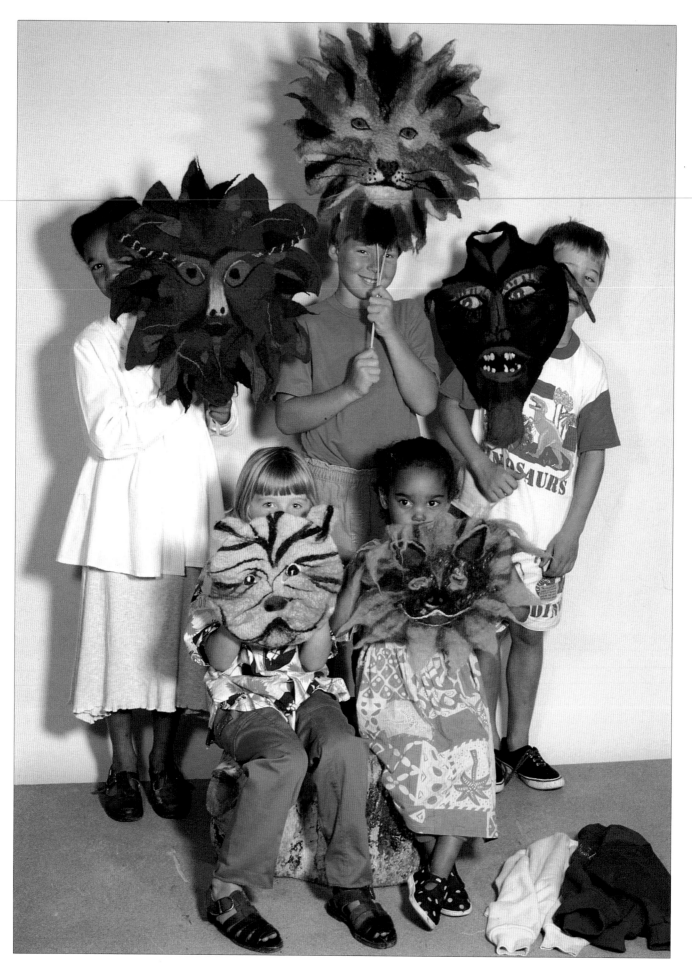

44

Masks

Making a mask takes the basic technique a little further, showing you how to shape wet felt and how to control a more precise pattern.

It is an ideal project for children, too, allowing plenty of room for imagination but resulting in something practical they can enjoy using afterwards.

You can make the mask a recognisable animal or a more mythical creature; whichever you choose, include plenty of detail, such as eyes, nose, ears, mouth, teeth, eyebrows, beard, moustache, shaggy mane, hair, plaits, whiskers, stripes or spots.

Make a sample beforehand with the fibre you intend to use, especially if you are working with children: it can be very frustrating for a child if the wool does not felt very well.

If you have plenty of dyed wool of the right colour, you can use that for all the layers; otherwise you can economise by having three layers of cheaper natural-colour wool and then one or two layers of dyed wool on top. In this chapter I am going to make the lion mask, shown at the top of the picture opposite, using about 125g (4oz) of combed tops in a variety of colours. The basic techniques of laying out, felting and shrinking are the same as for the earlier samples but with a few significant variations, the most obvious one being the shape; here I am making a circular piece of felt rather than a rectangle.

This toucan mask was made in two pieces which were sewn together over a wire frame and then fitted over a baseball cap.

Left
Lots of animals and mythological characters can be made into face masks.

Laying out

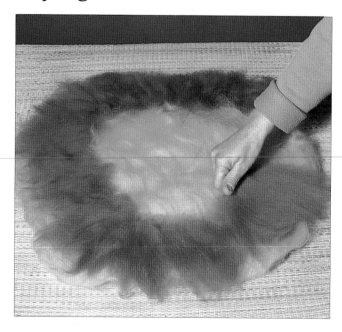

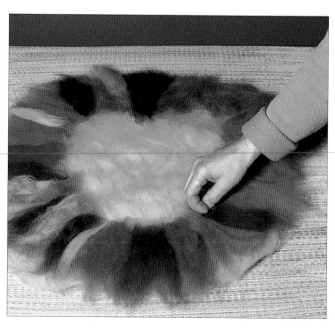

1. Lay out a circle of wool about 45cm (18in) in diameter with three layers of yellow wool and then add tufts of shades of orange around the outer edge for the base of the lion's mane.

2. Now build up the mane using tufts of different colours, using both dark and light, to give a shaggy result.

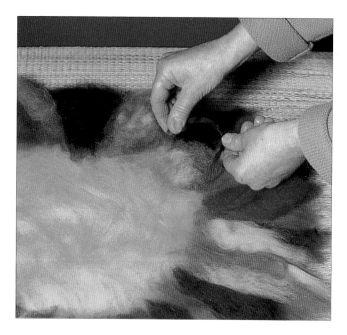

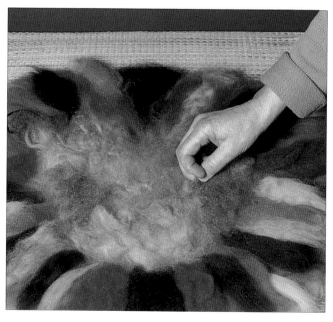

3. Take a good-sized thick tuft of light-brown wool for each ear, shape it into an oval and lay it down on the mane. Twist two small pieces of dark wool and place them around the top of each ear.

4. Next add some thin tufts of light-brown wool (I have used some camel down) for the cheeks and forehead, and some in a paler colour for the chin.

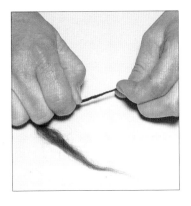

5. Take a small piece of black wool and twist it up very tightly to form a cord. Shape the cord into a pointed oval to form the outline of an eye. Make two of these.

6. Take a small tuft of orange wool, roll it up in your palms, flatten it and place it in the eye outline. Repeat for the second eye.

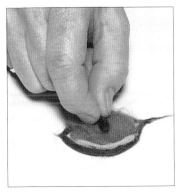

7. Make a thin cord of yellow and underline the orange eye. Take a tiny piece of black, roll it up tightly in your fingertips and place it in the centre of the eye. Repeat for the other eye.

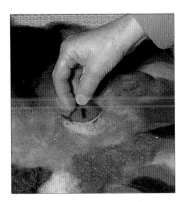

8. Shape some dark wool for the lion's nose and mouth and place in position, together with the two eyes.

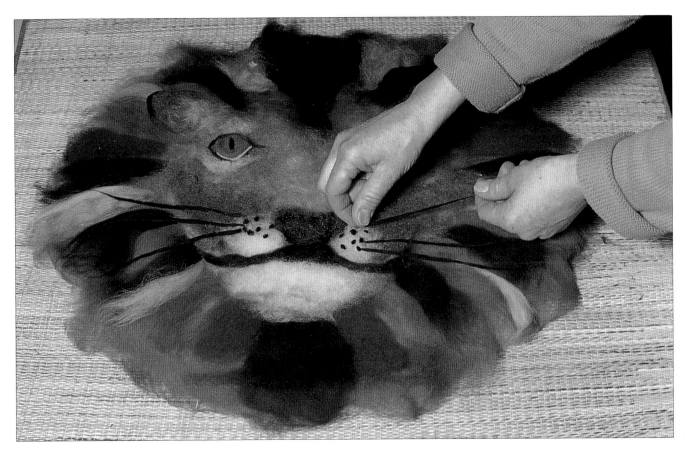

9. Twist up some more strands of black wool into long pointed cords and add as whiskers. Make some very tiny black spots and place around the nose to complete the design.

Felting

Felt the mask in the same way as shown on pages 32 to 34, but do not go right to the edge of the mane; you will want to have fleecy ends here. Work very gently at first so that you do not disturb any of the features. When the front side is all beginning to felt, remove the net, turn the whole thing over and work on the back. The presence of the mane can cause complications but just ignore it and turn in the first three layers of the yellow base. Cover the back with the net and, using hot water and soap, work all over the yellow felt, especially at the edges. Remove the net and turn the right way up.

At this point, check to see if any of the features have moved about and gently push them back into place. Never actually pull up the fibres; just gently nudge them around with your fingernail so that they do not break their contact with the base layer. Replace the net and give a final rub all over with water and soap.

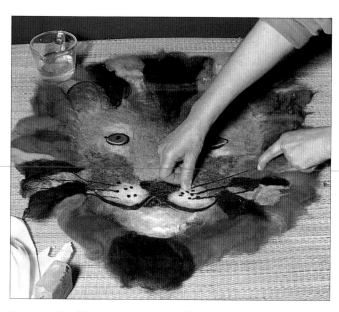

During the felting stage, carefully remove the net and nudge any details that have moved back into place with your fingernail.

Shrinking

Follow the shrinking stages given on pages 35 to 37 and ensure that you maintain a circular shape. After each rolling, keep pulling out the tufts of the mane so that they do not felt into hard edges.

When the felt is strong enough, you can lay it flat and tug it into the shape; pull up the ears, elongate the chin, or fluff out the hair. You can give the face a three-dimensional shape by laying it face-down on the table and placing your fist on the back of the nose (cheeks, chin) and pulling against it, rotating the felt each time you give it a good tug. The felt should be very strong by now, so you may have to really work at it, but by strategic use of thumbs, fists or maybe a wooden spoon or rounded stone, you can really change the shape, making the nose stick out and the eyes recede, and generally giving it a life-like look.

Rinse out the soap, squeeze out the water and leave to dry. If required, cut slits for your eyes and mouth and fix some elastic to each side.

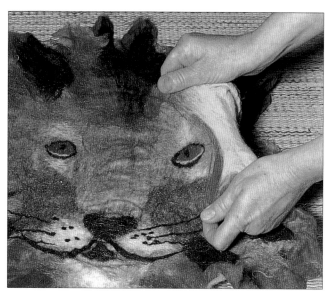

After each rolling, keep pulling out the tufts of the mane so that they do not felt into hard edges.

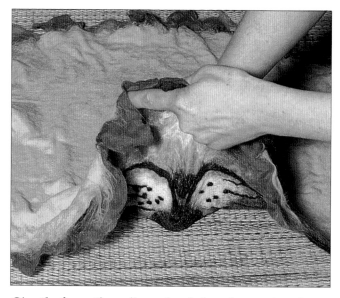

Give the face a three-dimensional shape by tugging the felt against a clenched fist.

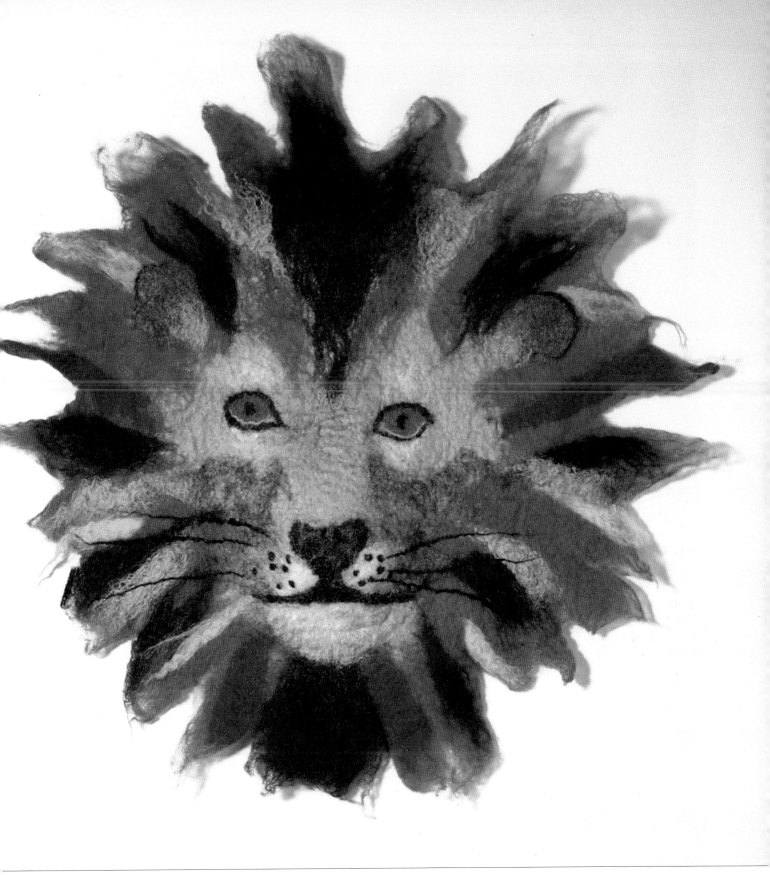

The finished mask.

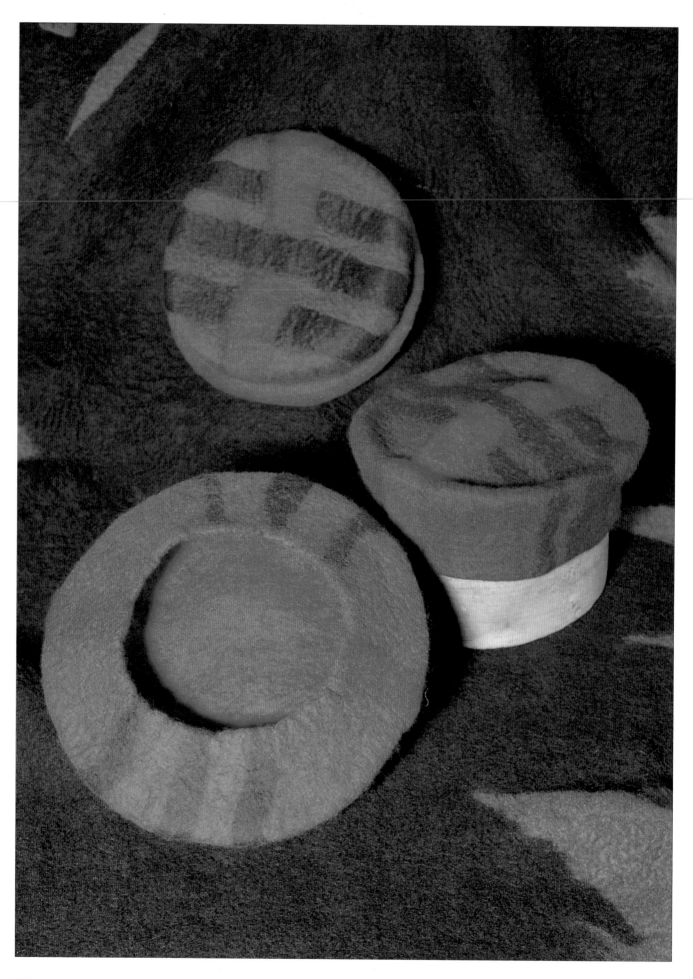

50

Making hats

COLEG LL... ...LLEC
LIBRARY RE...CENTR...
CANOLFAN ADNODDAU LLYFRGELL

I like designing and making hats from felt, and the methods shown on the following pages produce a seamless, one-piece hat. Although it is possible to cut and sew up flat felt, the technique of moulding a hat three-dimensionally is a much more interesting process. There is also a useful element of flexibility about the final shape, which you will appreciate when you get to that stage.

Once you have made a few hats in this way you will find that the method can be adapted to making many other things. Wet felt is easily moulded, using either a hat block or just your hands and head in front of a mirror. A few drips down the neck are inevitable but there is no better way to see how the hat is really going to look.

Again the basic techniques of laying down, felting and shrinking are as described earlier, but I am now going to make a real three-dimensional object using a calico template for the first time. There are also two other stages in the process; that of drawing in, which makes the sides of the hat and the headband, and shaping, which produces the final three-dimensional shape of the hat.

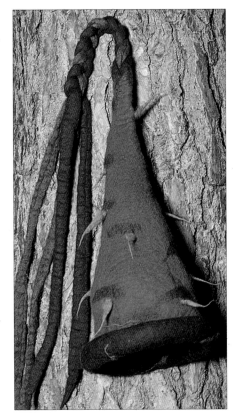

The stages shown on the following pages show how to make a beret, but by varying the diameter of the calico template, it is also possible to make a pill-box-shaped hat, or a hat with a rolled-up brim. Make a beret first and then try the variations.

When using combed tops remember to keep the fibres parallel in each layer. When using carded wool the pile will look much greater than an equivalent weight of combed tops, but this bulkiness is mostly air, and will flatten when you wet the wool.

The three types of hat that are demonstrated in this chapter are shown opposite. However, when it comes to designing hats, there are all sorts of possibilities. How about the pointed hat shown at the right, with its plaited locks, tassels and a rolled-up brim.

Size

The size of the hat is determined by the size of the calico template. The calico is going to get wet, so before you start making a hat, pre-shrink the calico by washing it.

You must make the template oversize, so that there is plenty of room for shrinkage as you work the felt. Sizing is not a problem because you shrink the hat until it fits.

For the beret, cut out a circular template 30cm (12in) in diameter, unless you want a particularly large and floppy one, in which case make it larger, say 37cm (14½in) in diameter.

The pill-box shape, which is far easier to make with an appropriate size of hat block, needs a slightly smaller diameter template – 29cm (11½in) – while a hat with a rolled-up brim requires a template that is 37cm (14½in) in diameter. If you know that your head is smaller or larger than average, or you have a lot of hair, add or subtract up to 10cm (4in).

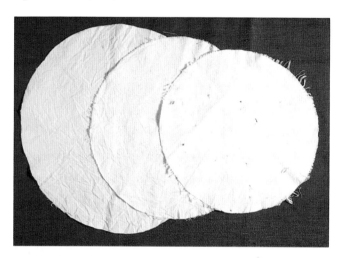

Calico template. From the left: rolled-up brim, beret and pill-box shape.

You will need about 95 to 125g (3 to 4oz) of wool to make an average size of hat, plus a few other bits and pieces for the pattern. If you are using a wool which is new to you, always make a sample first to see how it felts.

Decoration

The design possibilities are endless, but whether simple or complex, use your favourite colours and be bold. A pattern which radiates from the centre is much easier to control; so to start with, avoid a design which encircles the hat. Remember that the wool will move around slightly as it is felted, so do not hold too rigidly to a preconceived idea.

Laying out

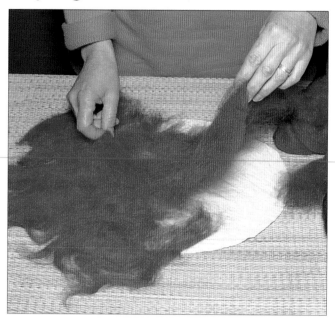

1. Place the calico template on the mat and lay down six layers of wool. For this hat the inside will be red and the outside blue, so make three layers of each colour. The wool should extend beyond the circumference of the calico by 8cm (3in). Keep a good circular shape as the layers are built up (try to avoid making any corners) by adding smaller tufts around the edges.

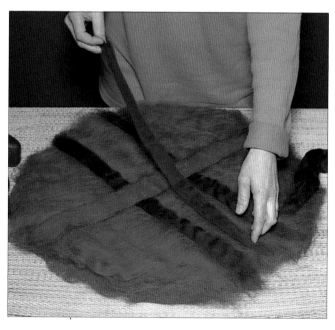

2. When you have completed the last blue layer, add the pattern. Remember that the area over the calico is the top of the beret, and that the extra 8cm (3in) forms the sides, which are the most visible parts of the hat when it is on your head.

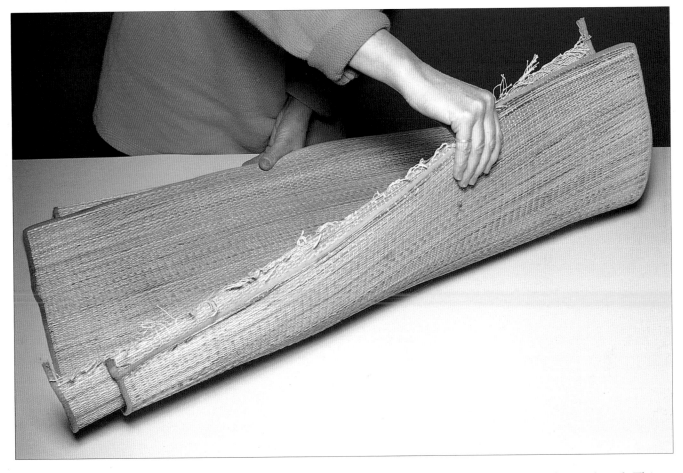

3. When you have something to your liking, turn the whole thing over. This is easily done with another reed mat. Make sure that the reeds run parallel in both mats and flip them over; nothing should be disturbed. Alternatively, you can place something that is flat and shiny (a record sleeve for example) on top, flip the whole thing over and then gently slide it out from underneath.

The inside of your hat is facing you, with the calico on top. If you want a pattern on the inside, remove the calico, add the design and then replace the template.

Felting

Felt only the area under the calico; it is important to avoid wetting the wool around the edge. Pour hot water into the middle of the calico then gently rub in the soap. Use the fingertips of both hands to smooth down the calico carefully; then gradually saturate and flatten the entire template. Use only just enough water and soap to avoid any seepage into the surrounding wool.

When the calico is completely flat, continue felting by slowly increasing the pressure, rubbing more vigorously with the flat of your hand. This can take up to twenty minutes. Peel back the edge of the calico and do a pinch test to see how the wool is felting. If it is still very loose, do some more rubbing, perhaps using hotter water.

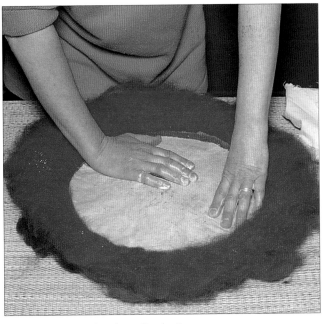

Felt the area under the calico only.

Drawing in

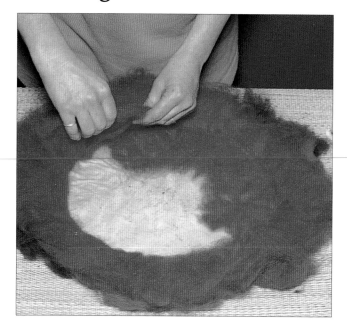

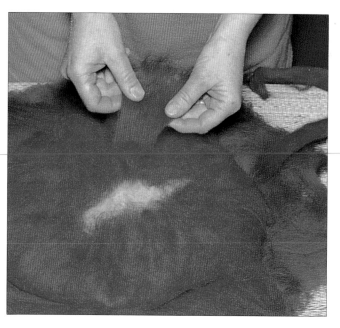

1. Turn in the layers of dry wool one at a time, leaving a hole in the middle.

2. Add more tufts of wool to fill any gaps, keeping their fibres in the same direction as each layer. Distribute the fibres evenly, so that the thickness is the same as underneath the calico.

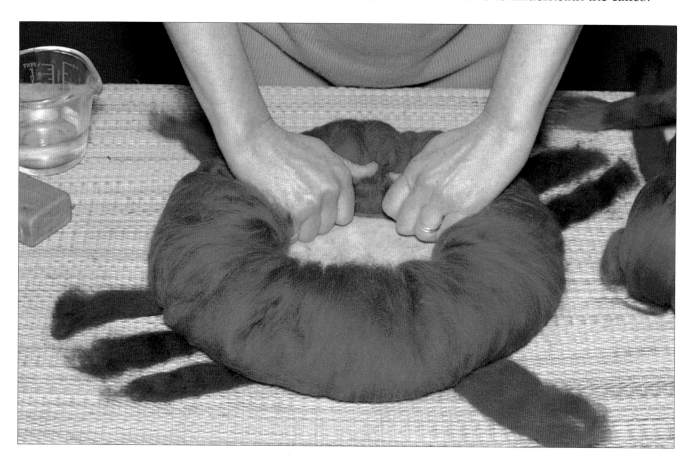

3. Now form the central hole (the rim) by curling the wool back under the sides. The central hole should be about 15cm (6in) in diameter – this may seem rather small but it will result in a good strong edge when it has been stretched to fit.

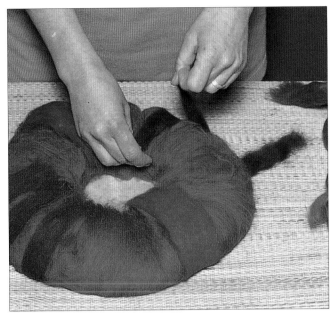

4. Bring over the pieces of wool that make the pattern and tuck them under the rim if necessary.

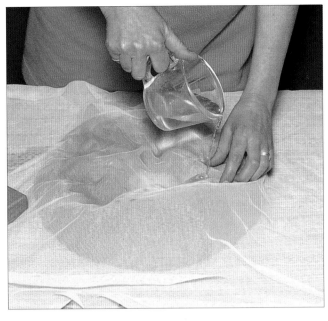

5. Cover the hat with a piece of net, pour on some hot water and use your knuckles to press the water through the net into the dry wool.

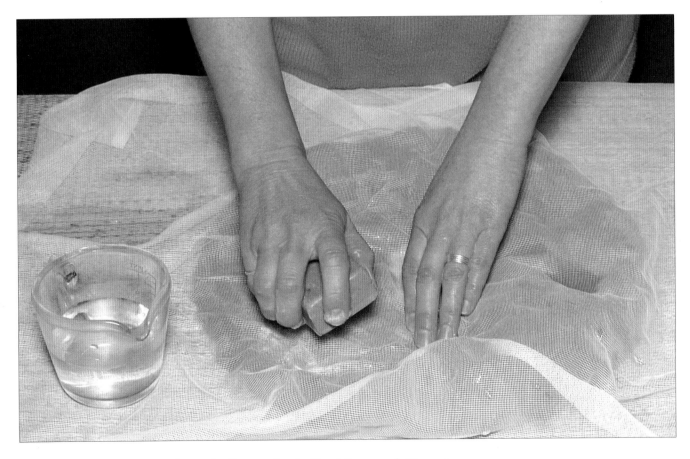

6. Dab on some soap and gently flatten the bulk of the wool. Do not rub just yet; simply push down with your fingers to get the soap and water well worked into the wool.

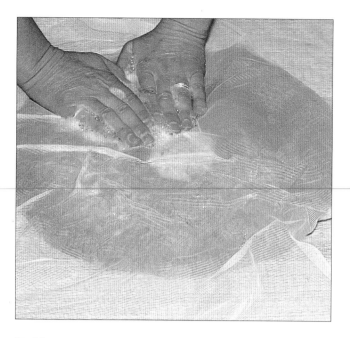

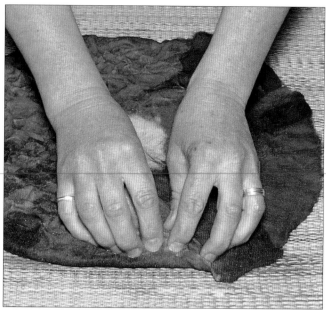

7. Now press down with your palms to start the felting of the turned-in sides.

Peel off the net, taking care not to remove any wool. You will note that the shape has spread out (it is now larger than the calico template), because wool expands on first contact with hot water.

8. Restore the size to the diameter of the calico inside. To do this, thoroughly soap your hands and, using your fingertips, work the soapy wool back into shape. You should be able to feel the calico edge as you work your way around the circle. If there is any doubt, carefully slide your fingers inside the hat to find the edge, but not too often or you will stretch the rim.

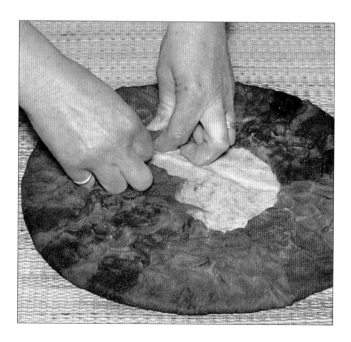

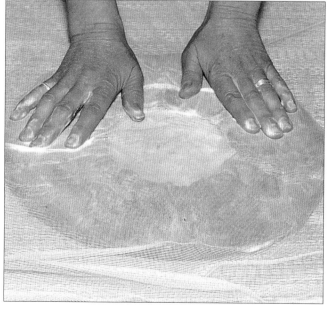

9. Now work on the inner edge; tuck in the wool so that it doubles up and strengthens the rim. Retain a diameter of 15cm (6in). You should now have two concentric circles with an even thickness of wool between them: the circular shape and its evenness are important, but do not worry about a wrinkled surface at this stage.

10. Replace the net and gently rub for a minute or two, with soap and a little hot water, so that the wool really starts to felt. Remove the net and repeat the drawing-in process (stages 8 and 9), keeping to the two concentric circles. Repeat this stage five or six times until the wool has felted sufficiently to stop moving beyond the edge of the calico, and the hat begins to feel more solid.

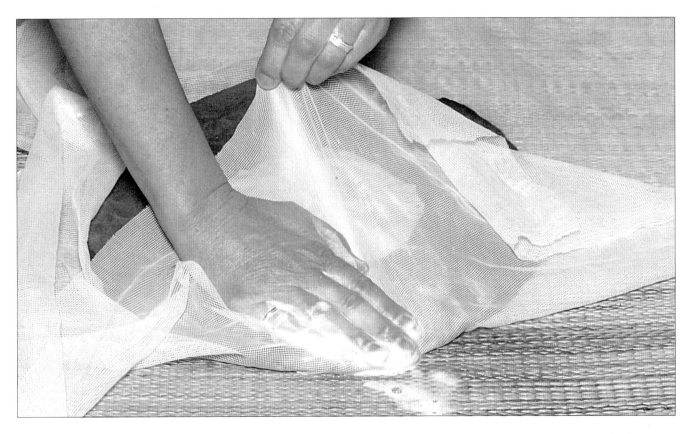

11. The wool will become very wet and soapy, so put the net underneath, wrap it loosely over the hat, roll up carefully and gently squeeze out some of the water – but do not wring it.

Lay the bundle down on the surface, open up the net and check that you still have two concentric circles and that the outer diameter is the same as that of the calico. Pull a section of the net towards you from the far side of the hat. Pour some hot water on the felt under that part of the net, use more soap, and rub vigorously with one hand, keeping the net under tension with the other. This allows you to apply more pressure on the edge of the hat because it is being contained by the tightly held net. Keep adjusting the inside rim to ensure that this is strong, regular in thickness, and the right size. Work on each section of the felt, moving around the circle, until you have covered the whole hat. By now the felt should feel quite compact and no longer soft and fluffy.

Shrinking

Roll the hat up in the mat and then some sheeting and start the shrinking process. Work slowly and carefully, rotating the piece so that the circular shape is maintained. Do not work too hard; you do not want to shrink it too much. Stop when the calico inside begins to wrinkle up. Remove the calico.

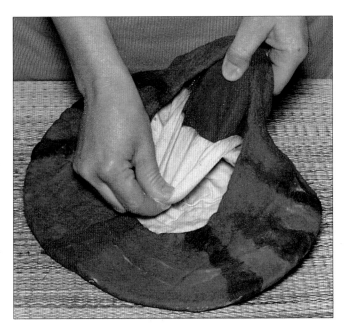

When you have completed the shrinking process, remove the calico template.

Shaping

You must now transform the rather flat hat into a rounded bowl shape. You will also have to adjust the size of the rim.

BERET

Work on a small part of the outer rim at a time, using more hot water and soap. Use both hands to rub away the sharp edge of the outer rim until it is a nice smooth rounded shape. Rinse out the soap with cold water and squeeze hard. Your hat is now nearly ready.

Now see if your hat fits; work in front of a mirror and do have a towel handy. It will probably be too small, so pull the rim to stretch it. You will find that the felt is very strong – keep stretching it and trying it on until it is just right. If the hat is much too small, stretching it may involve a fair amount of force; if you put one foot on the floor inside it and heave upwards this exerts more pressure than simply pulling with your hands. If the rim is too large, you can reduce it as shown on page 60.

Felt is extremely flexible in this state, so use this quality to your advantage, and pull and push the hat into the shape which suits you best. When you are satisfied, leave to dry in a warm place or on a towel, keeping it in its desired form. This is the simplest shape.

ROLLED BRIM

Make the hat in the same way as the beret but use the larger template. At the shaping stage you must stretch the inner rim to give a loose fit on the head; the headband will get smaller as the rim is rolled up. Now use the fingers and thumbs of both hands to roll up the edge and tuck in the rim, working your way round and round.

Try rolling a thicker or thinner brim. You can also try stretching the crown a little to give it more depth. It will stay put if you work it sufficiently and then let it dry in position.

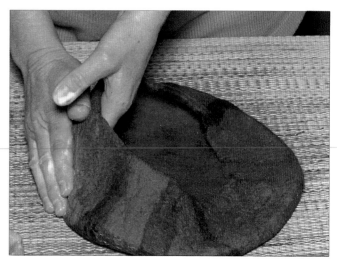

Work on a small part of the rim of the beret, using your hands to smooth out the edge.

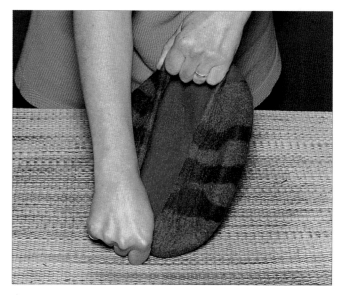

If the headband is too small, stretch it by pulling; you may have to use quite a lot of energy!

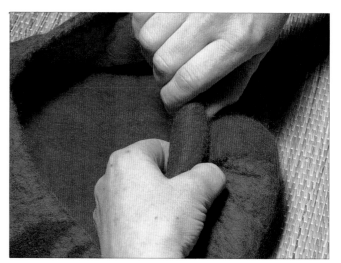

Use your fingers and thumbs to roll up the brim.

PILLBOX

To make a pillbox-type hat of a very precise shape you will need a hatblock. However, it is possible to make a similar shape without using a block; you simply work the felt with your hands, placing your fist on the inside to act as a former.

Make the basic shape as for the beret but use the smallest size template. Stretch the rim of the hat until you can fit it on the hatblock or your head. Make sure that the edge of the rim is even, and that the sides are the same depth all round. Use hot water and soap and start to massage the felt, taking care to keep the top of the hat well centred. You can rub away the fullness in the top of the hat quite quickly, so that the felt begins to take the shape of the block. Remove the hat before it is completely shrunk, rinse it out and try it on (you may find that you prefer a slightly softer shape). When you are happy with the shape of the hat, rinse it out, reshape it and leave it to dry on the block. If you are not using a hatblock, work the felt by more rolling and rubbing until it is roughly a pillbox shape.

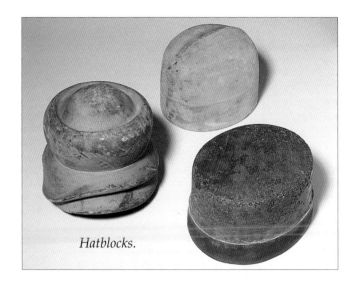

Hatblocks.

Massage the felt with soap and water to mould it to the shape of the hatblock.

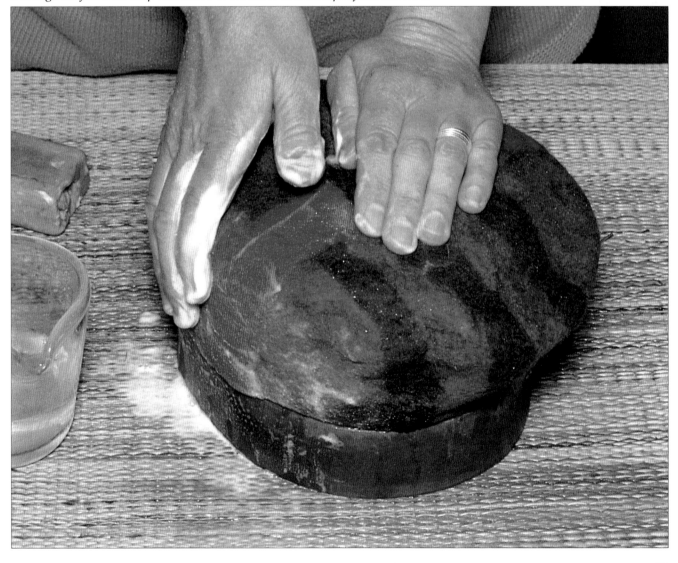

Reducing the headband size

Sometimes the rim ends up too large, but you can tighten it up.

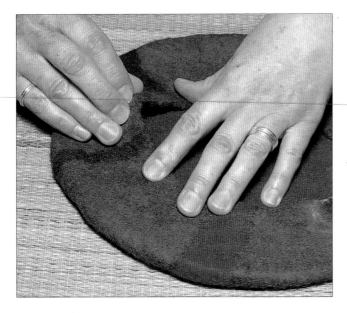

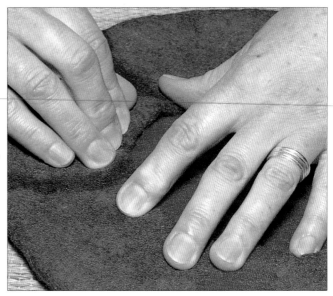

1. Work on a mat and trap a generous section of rim between the thumb and forefinger of one hand.

2. Pour on some very hot water and use the fingers of the other hand to press the felt down, forming a tighter segment of the headband.

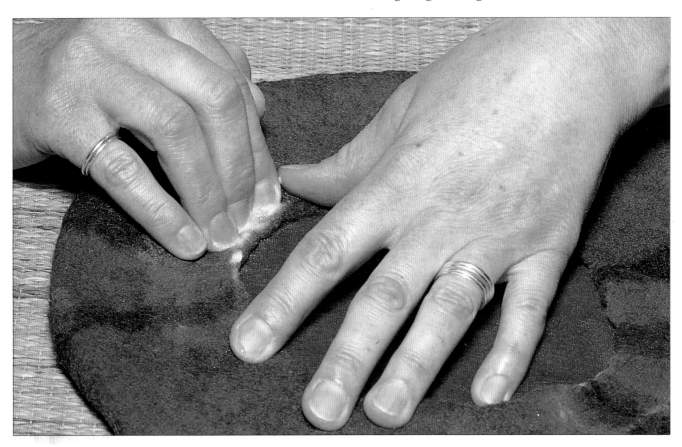

3. Rub in some soap and work that small area with your fingertips to shrink it. Work your way around the hat until the hole is small enough. Do be careful not to rub all of the hat or the whole thing will diminish in size.

Variations

Try using different colours of wool on the inside and outside of your hat; this is especially effective on a rolled-up brim as it gives a good contrast. It is possible to make your hat reversible. If you decide you prefer the inside, simply dunk in hot water and turn inside out, reshape and dry. You can do this at any point in the life of the hat if you wish to change its shape.

Above
A hat made in two pieces, with a heavy plaited brim.

Left
One-piece hat with points, and a seamless waistcoat with in-built pockets.

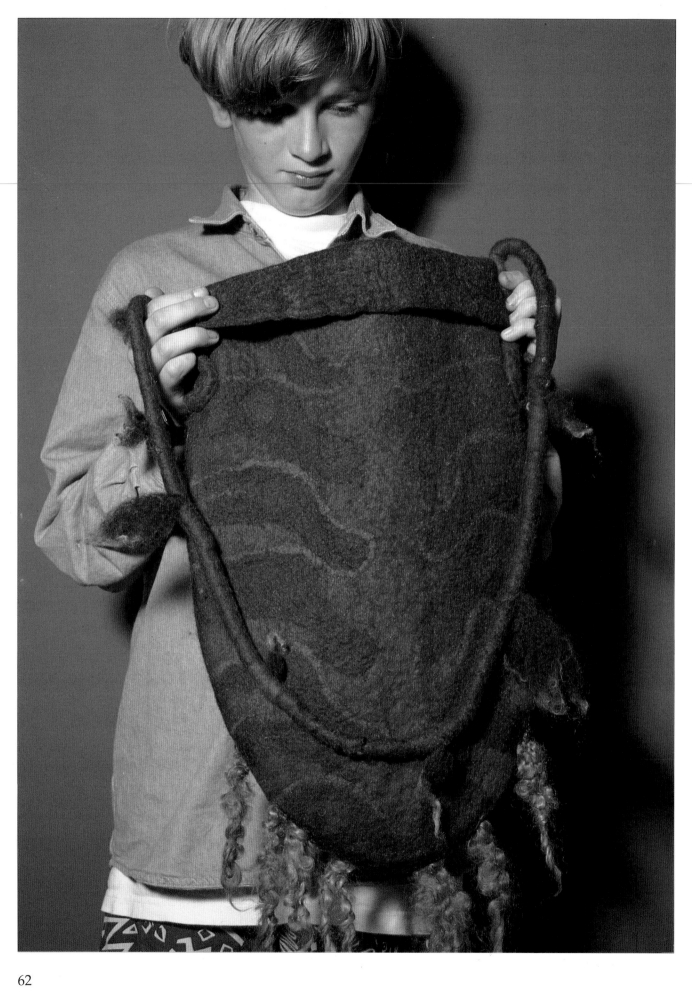

Bags

Where nomadic people have to transport their belongings in a well-ordered fashion, there are felt bags designated for particular uses; as bread pouches, baby carriers and saddle bags.

Bags are made in much the same way as the hats in the previous chapter except that the calico template is completely enclosed with felt and the top opening is then cut through with a pair of scissors.

There are endless variations of size and shape, from a small purse, which is a good project for children, to much larger carriers, or even a sleeping bag. You can make a bag any size or shape by simply altering the proportions of the calico pattern.

Many of the techniques used to make bags are the same as those for making hats, so refer back where necessary.

You will need up to 350g (12oz) of wool to make a bag. The actual amount you use will, of course, depend on the size of bag you want to make. As usual, I would suggest that you make a sample piece of felt with your chosen wool before starting work on the bag itself.

In this chapter I am going to show you, step by step, how to make a simple pouch-type bag that has a turned-back top and a sewn-in handle (see right). I also explain how to make two other types of bag; one which has an integral handle and another with a folded-over flap.

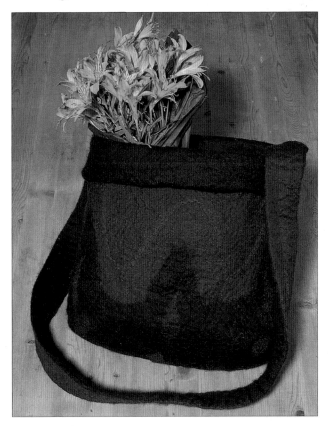

Right
The project bag – a pouch with a turned-back top and a sewn-in handle.

Opposite
This pouch was made entirely from natural dyed wool. The handle was made from felted woollen cord.

Laying down

1. Cut a calico template to the desired shape. I am using a rectangle that measures about 30 x 45cm (12 x 18in). I have also belled the bottom end and incorporated well-rounded corners to give the bag more stability.

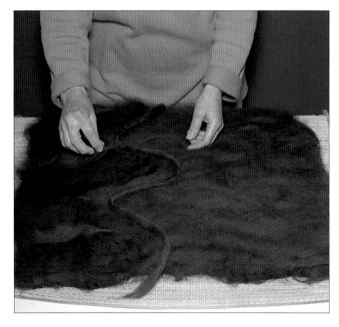

2. Lay out six layers of wool, overlapping the template by about 10cm (4in) all round, and then lay a pattern on top. Try using three layers of one colour and three of a contrasting one. This will mean that the inside of the bag is a different colour from that of the outside.

Felting

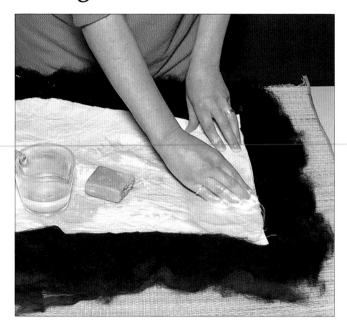

1. Turn the assembly over so that your pattern is underneath and the template is on top. (Use the technique shown on page 53.) Now start felting down on to the calico, keeping the wool that lies beyond the edges of the template dry.

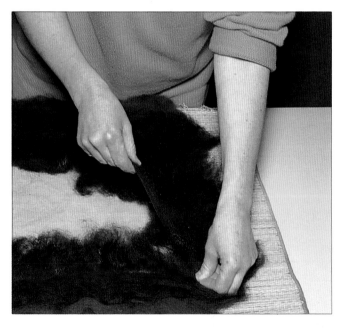

2. Fold in the surrounding wool one layer at a time. At the corners you will have two thicknesses folded over so remove some from each side to maintain an even layer of wool. Fill any gaps in the middle with more wool.

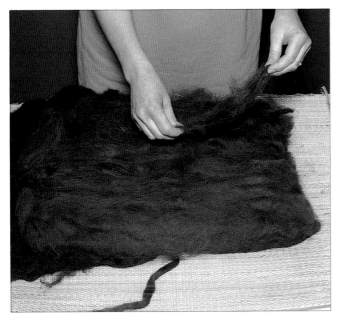

3. Repeat stage 2 until all six layers of the bag have been turned in and filled in.

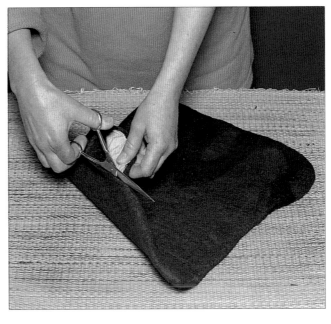

1. Follow through the drawing-in and shrinking processes (basically as given for the hat – see pages 54 to 57), rolling and turning the bag until the felt is stable and compact and fits closely around the calico template. Now carefully cut through the top edge of the bag with a sharp pair of scissors.

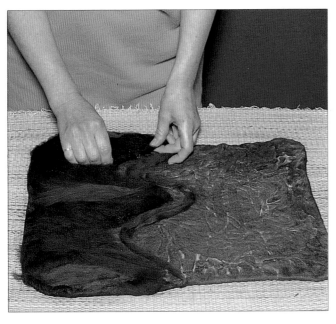

4. Pre-felt the wool of the bag and then turn in the dry wool of the pattern. Ensure that the pattern follows on round the edges of the bag.

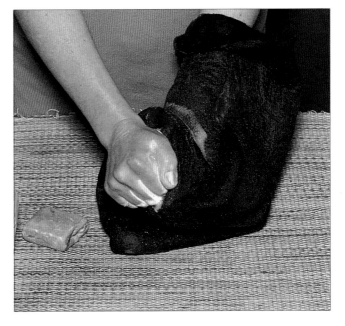

2. Pull out the calico template and then work the bag from the inside to shape and strengthen the sides. Make a fist with one hand and work on the bell-shaped bottom corners with the other to give the bag a flattened base for stability. Use more soap and water and work on the cut edges at the top of the bag to smooth out any sharp edges.

3. Finally, construct a handle and sew it on when the bag has been rinsed and dried. You can make a carrying handle in many different ways: a piece of cord sewn on or a very strong strip of felt stitched double or rolled up and sewn along its edge, possibly even with a cord inside. Sew the strip on well down inside the bag to ensure enough strength. You can obviously line the inside if you wish.

You can experiment with all shapes and sizes of bag – from a small purse upwards. On the opposite page I tell you how to make two variations: a bag with an integral handle and another with folded-over flap.

The finished bag.

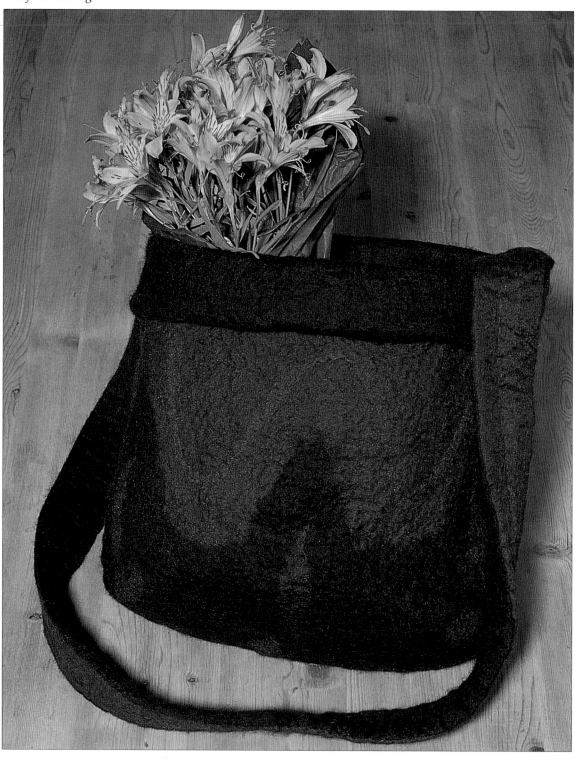

A BAG WITH AN INTEGRAL HANDLE

Cut out a calico pattern with a handle; lay out as usual, but for the handle use several single lengths of combed tops if you can, to give added strength. Fan out the ends into the body of the bag. When felting, fold the opening edges of the bag under, but leave the very top of the handle dry until the rest of the bag is well felted. You can then carefully lay the two sides of dry wool over each other, wrap around with a small piece of net, and, using plenty of soap and a little hot water, felt them together to make a good strong join. If worked properly the join will be invisible.

A bag with an integral handle.

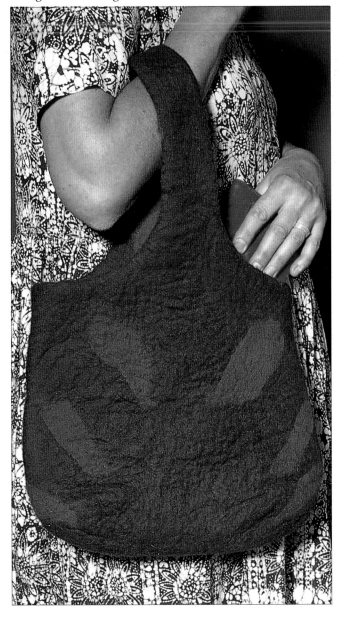

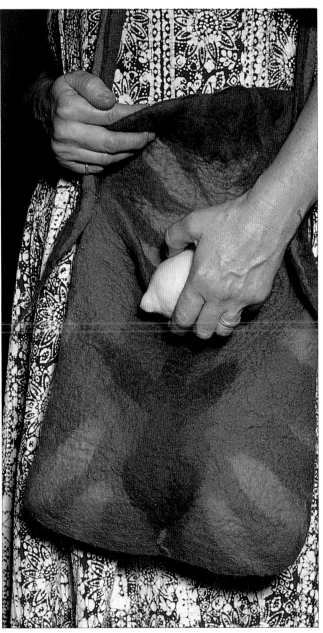

A bag with a folded-over flap.

A BAG WITH A FOLDED-OVER FLAP

Cut out a calico pattern to include the flap, which may be about one quarter of its total length. When felting, tuck the extra 10cm (4in) of wool under the calico flap to give a uniform edge, taking great care with the corner where it joins the mouth of the bag. Otherwise proceed as usual, building up the six layers for the front of the bag and then following through all the other stages to finish with shaping. Then construct a handle to be sewn on later.

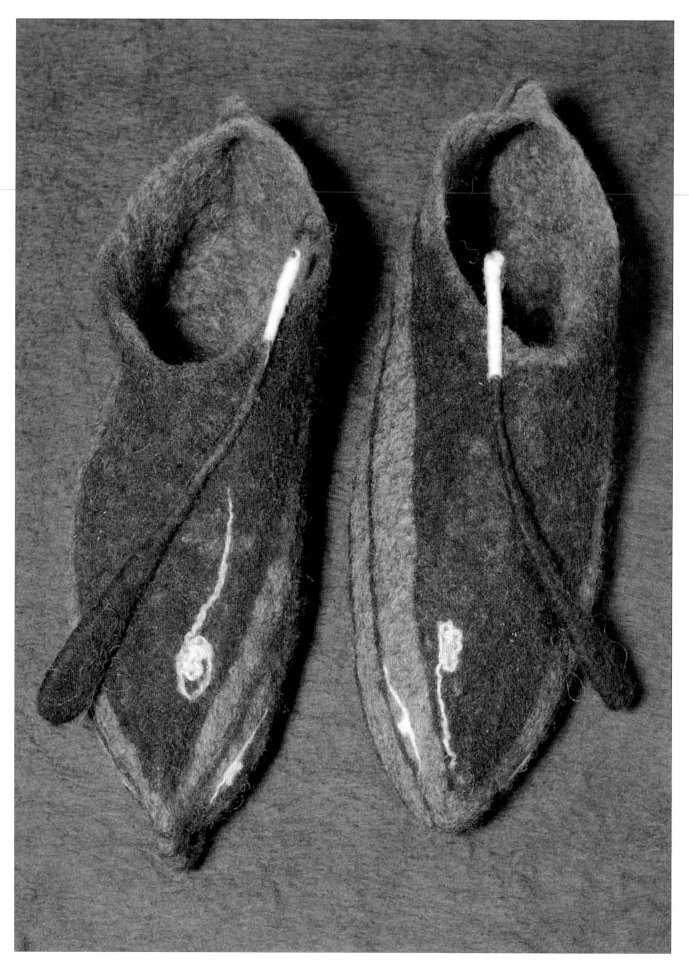

Slippers

Once you have made a few hats you will be skilful enough to try a pair of slippers. This is another one-piece method: you felt the wool around a calico template which is later removed by cutting the felt open at the top. You make the slippers very large to start with and then put them on your bare feet to shrink them, rubbing with hot water and soap until they are just the right size and shape.

You will need a total of 175 to 350g (6 to 12oz) of wool, depending on shape and size, to make a pair of slippers.

Use eight layers of wool so that they are thick enough to be wonderfully warm and durable; and you can then reinforce them as well by adding an extra felt and/or leather sole.

It is best to work on both slippers at once. Should you need to stop and do other things, you can leave the process at any point and return to it later or even the next day. Use two beach mats with a template laid on each; you do not have to worry about left and right.

Opposite
Boat slippers: each seamless slipper is decorated with a wired oar which is sewn in place.

Right
The project slippers.

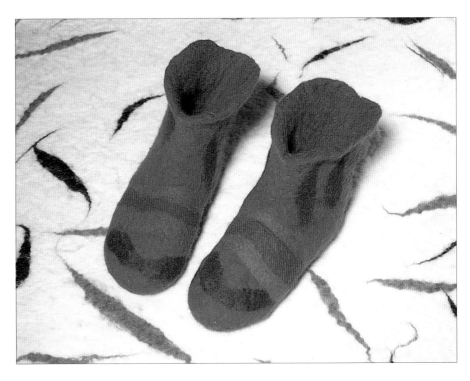

Shape and size

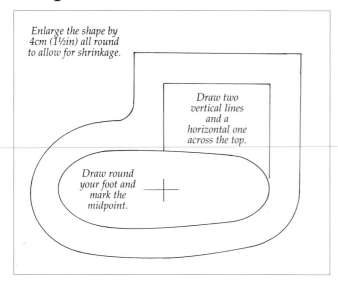

Enlarge the shape by 4cm (1½in) all round to allow for shrinkage.

Draw two vertical lines and a horizontal one across the top.

Draw round your foot and mark the midpoint.

Stand barefoot on a piece of paper and draw a pencil line around your foot. Now mark a point halfway between heel and toe and draw two vertical lines, one from the heel end and one from the mid point, to form the neck of the slipper. Draw a horizontal line for the top of the neck – see the diagram. Vary the height of the neck as you wish, from below the ankle to almost up to the knee – but smaller is definitely easier to start with. Now enlarge the shape by 4cm (1½in) all round to allow for shrinkage.

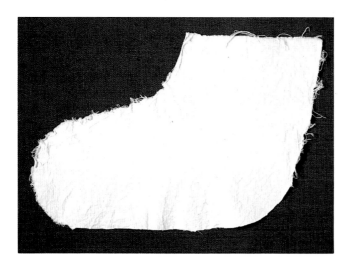

Cut out your paper pattern, transfer it on to some pre-shrunk calico and then cut out two templates.

Laying out and drawing in

These slippers are made from eight layers of wool. To make things easier, I usually lay out, draw in and pre-felt four layers of wool over the template and then repeat the process with a second four layers, before going on to final felting, shrinking and shaping. Divide the wool, by weight, into two halves; use one half to make each slipper.

FIRST FOUR LAYERS

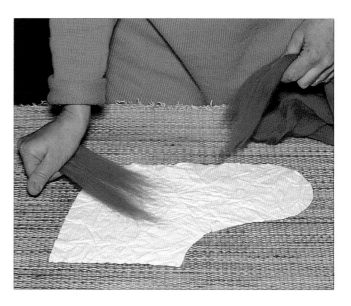

Lay out the wool over the template, layer by layer, making each layer of an equal thickness. Lay the wool for each layer in opposite directions if you are using combed tops, and make it extend an extra 8cm (3in) beyond the edge of the calico.

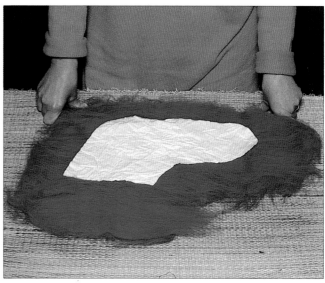

Turn the wool over so that the template is on top and start felting the area of the calico, keeping

the surrounding edges dry. Continue only until the calico is quite flat – the wool does not have to be completely felted. Do this on both slippers.

Draw in the dry wool round the edges, one layer at a time, as for the hats and bags, always aiming for an even thickness. If you have too much wool around the heel and toe, thin it out a little by gently removing tufts. These can then be used to fill in the middle area, together with more wool if necessary.

Place a net over the wool and felt again. As with the hats at the same stage, the wool will expand, so follow the stages on pages 54 to 56, working only until the wool starts to compact.

Do the drawing in two or three times, or just enough to re-define the shape of the template; if you go too far at this point, this layer will not felt easily with the next ones.

SECOND FOUR LAYERS

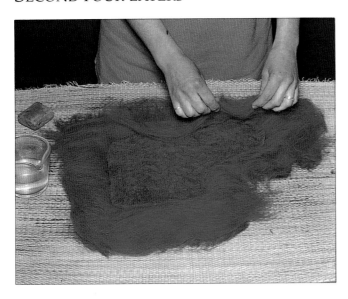

Leaving the slippers as they are (part felted), lay on the next four layers of wool in exactly the same way as before, again allowing an extra 8cm (3in) around the edge. You will now have a total of eight layers for each slipper.

Place a net over the slipper. Working from the middle, using a little hot water and soap, gently press down with your fingertips, feeling for the edge. Avoid wetting the extra wool and only rub gently for a few minutes, just enough to start the felting process. Remove the net.

Turn both slippers over and start to draw the wool inwards as for the first four layers. Replace the net and start to felt these layers, but again, only until the wool starts to compact. When you have done this, wrap the slipper up in the net and gently squeeze out some of the cold water.

Decorating

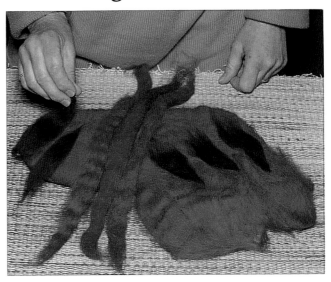

Now you can lay on the decoration. Work on both slippers at once, so that you can match them up if you want to. Remember that the parts that will show most are around the rim and the toe, not the lower half, which will disappear underneath the sole. It is also a good idea to use patterns which run over and beyond the edges; leave the tufts hanging free, ready to be continued on the other side. These will felt more easily than any wool that is placed parallel with the edges.

Final felting

Replace a net and then rub gently with some very hot water and soap. Very gingerly remove the net.

Turn the slipper over and finish the pattern on the other side, carefully joining in any protruding tufts of wool. Place the net on top and felt down the pattern on this side, using hot water and soap. Both slippers are now decorated and partially felted. With the net underneath, wrap up each slipper and squeeze out most of the soapy water.

It is important to ensure that the felt fits tightly around the enclosed calico template. If the shape has grown beyond the edges of the calico, you will have a ridge down the front of the slipper and another underneath it. The removal of these ridges will involve extra work later on, so avoid this if you can: keeping the net underneath, work the edges as shown for the hats on page 56.

If you have problems making the pattern stick, squeeze out the water, cover with net and pour boiling water on the troublesome bit. Use some more soap and rub for about five minutes without removing the net. By now the slippers should be well felted and of a similar shape and size.

Shrinking

Using the basic technique of rolling the felt in the mat and sheeting, gradually work the slippers from all directions until they are really compact. Next, make an incision at the top edge, poke in the scissors and cut a line across, stopping short of either end (you can adjust the size of the opening later) and then pull out the template.

Shaping

Put one hand inside the slipper and make a fist in the toe. Start to shape the slipper with your other hand, rubbing with hot water and soap. Gradually massage away the inevitable ridges; you can do this by using the thumbs of both hands literally to pull the thickness away. Be aware of the shape you are aiming for, possibly working away some of the fullness at the toes and heels.

Now for the interesting part of the process! Put a slipper on your bare foot (you soon get used to it) and start to massage the felt using hot water and plenty of soap. Rub away at the toes and heels, keeping your foot well forward inside the slipper. Put your feet down flat on the floor occasionally to check on the shape. You can trim the tops with scissors to tidy them up – if the tops are too long try folding them over – and felt the edges a little to strengthen them.

Work on both feet evenly, gradually shrinking the slippers down to your size. Do be careful not to go too far or you might have to cut the felt to get your foot out! Remember you will probably be wearing socks inside them.

When you are happy with the size and shape of the slippers, rinse out all the soap and squeeze out as much water as you can. Reshape them and put them somewhere warm to dry.

Extra soles

Reinforce the sole by making a really thick piece of flat felt. Remember to make it large enough to allow for shrinkage, then cut out two soles. Sew them on with strong thread. This will extend the life of the slippers considerably as it is really only the soles that wear out. Stitching on some leather is also a good idea as wool is slippery on wooden floors and stairs, or even do both for really durable footwear.

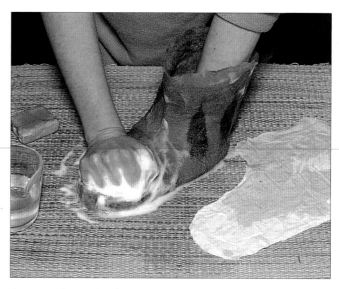

Start to shape the slipper by massaging it over a fist.

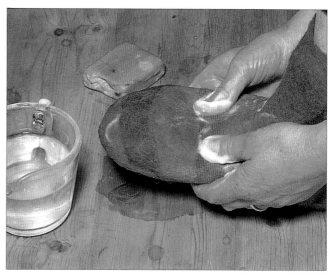

Massage the slipper down to size on your foot!

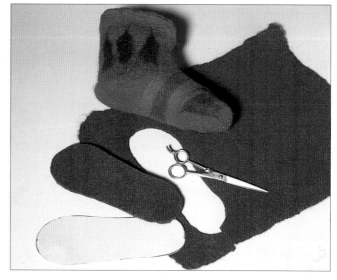

Make up an extra sole from a sheet of thick felt.

The finished slippers.

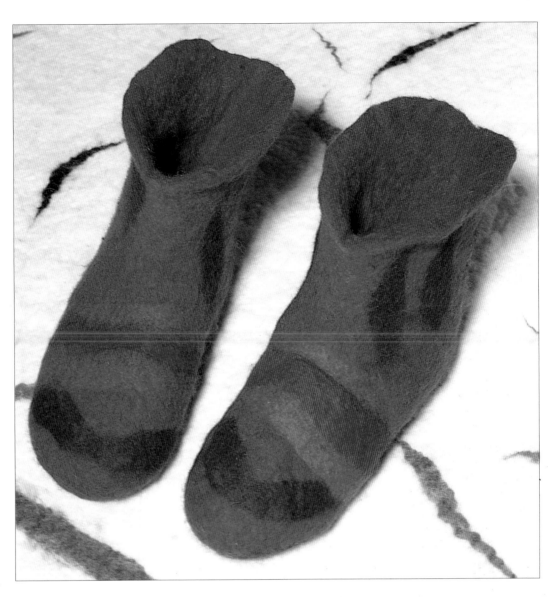

*Two more exotic
designs of seamless
slippers.*

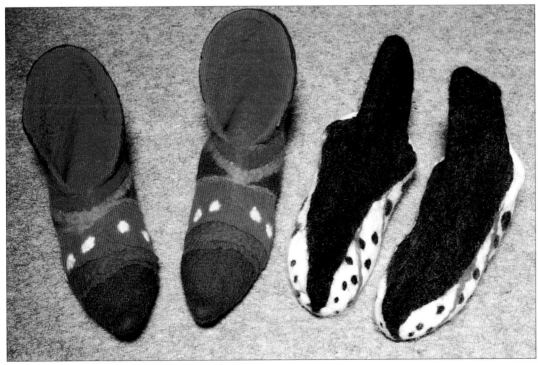

73

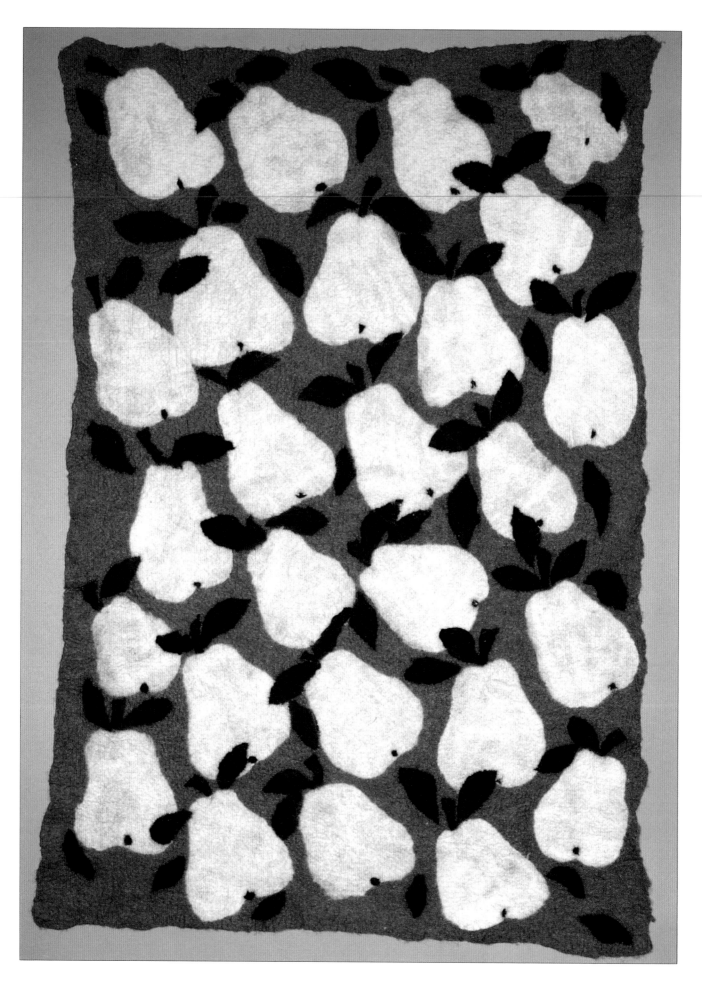

74

Rugs and other large felts

These are made in the same way as small flat pieces of felt, so in some ways they are simple, but because you use a larger quantity of wool, the whole process does take much longer. Depending upon size, it can also be quite hard work, but your end result will make it all worth while. Try working with other people on these larger pieces. A floor rug needs to be felted really well, so that its surface is very compact, to withstand hard wear.

A rug needs to be nice and thick, so choose your wool carefully – you can use one of the coarser types. You will also need quite a lot of wool, so you can economise by using cheaper or undyed wool for the bulk of the rug and only use the colour that you wish to be visible for the top three layers; this will provide a good background for your surface design.

Blankets, wall hangings and items of clothing need much less felting; you can make some wonderfully warm, soft coverings, with countless choices of colour and design. Use a softer wool for blankets and clothes. Wall hangings can be made of almost anything: it is a good chance to experiment with different fibres, as strength is not an important consideration.

Think about all the various techniques such as inlay and mosaic when planning your piece. It is a good idea to make some small samples first just to see how they look, and also to experiment with thickness and shrinkage.

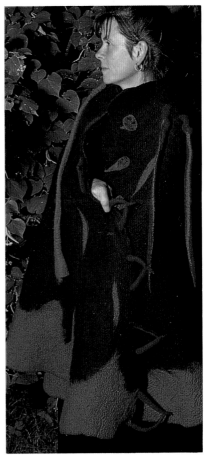

Right
Cloak with felted epaulettes and other intricate fastenings.

Opposite
Pear blanket made using the inlay technique.
It measures 110 x 120cm (42 x 48in).

Laying out

You will need about 2kg (4lb) of wool to make a rug 1m (36in) square and about 700g (1½lb) for a blanket 1 x 1.5m (36 x 60in). The amount of wool needed for wall hangings will depend entirely on the size and thickness of the piece. Work on a large cane window blind.

Lay out the wool the same way as usual, layer by layer, ensuring that each layer is even in thickness. A rug will need about ten layers of wool and a blanket about three or four layers. Use these as rough guides only, as it depends a great deal on your wool and what you want to make. If you like, you can lay in some fringe around the edges.

Felting

Follow the instructions for the basic technique on page 32 to 34. For larger pieces you could work on the floor, using your bare feet instead of your hands to rub in the soap and water. Get some help: children are wonderfully enthusiastic felters.

Keep a constant check on any fringes, or they will felt back into the rug/blanket. Work your way around, shaping and pulling them free.

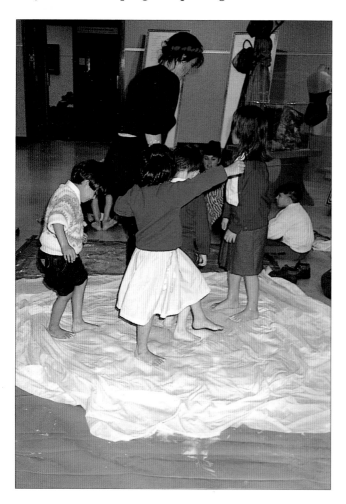

Shrinking

Wrap the piece in the cane blind and sheet and, using the rolling process, shrink as usual. It can help to tie the roll tightly with some lengths of cord so it does not come undone.

When rolling a large felt I find it easier to work on the floor, using my feet. Stand a chair in front of you to lean on and roll the felt to and fro, using each foot in turn. This method also exerts more pressure, as your body weight is above the roll. Alternatively, you can work on a table, using your hands or your forearms.

Work from each edge as usual, turning the felt round in the blind. Push and pull the edges into a good shape, especially the corners. If you fringed the felt, work away at it to keep it uniform.

For blankets, stop while the felt is still soft and supple. With rugs you just have to roll a long time.

When you stop and rest, stand the roll in a bucket, or outside, so that the cold water can run out. Then when you start work again, open out the felt and pour boiling water on to it before you roll it up again. Repeat this method of removing the cold and replacing with hot, as it will speed up the felting process considerably, saving you a lot of effort.

When the shrinkage is finished you can spin-dry the felt. However, this will mean that it needs flattening out again afterwards; or you can simply hang it up to drip and eventually dry.

Children having a great time felting a large piece of felt with their bare feet.

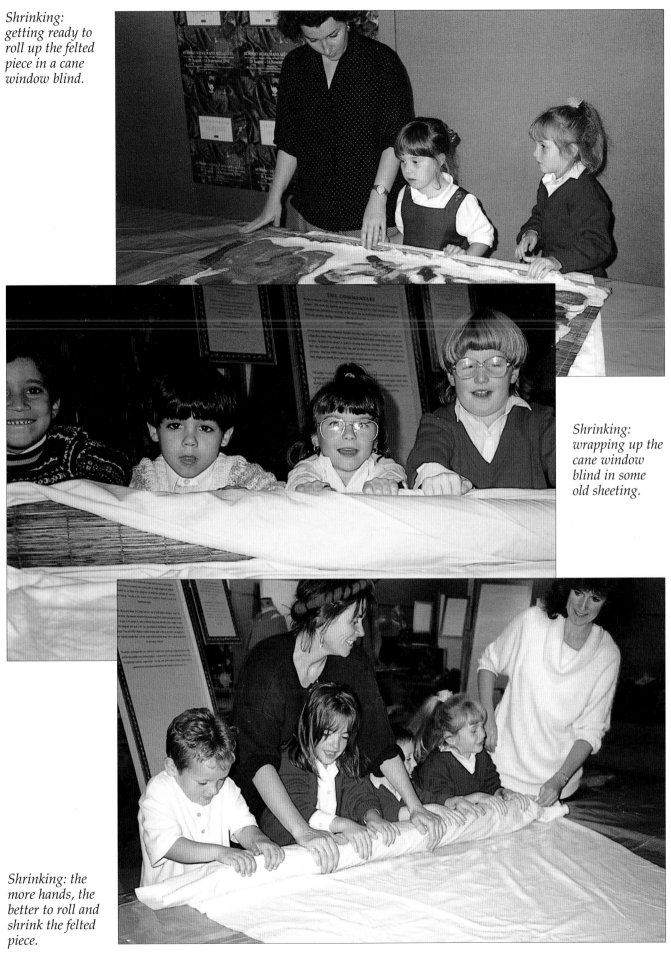

Shrinking: getting ready to roll up the felted piece in a cane window blind.

Shrinking: wrapping up the cane window blind in some old sheeting.

Shrinking: the more hands, the better to roll and shrink the felted piece.

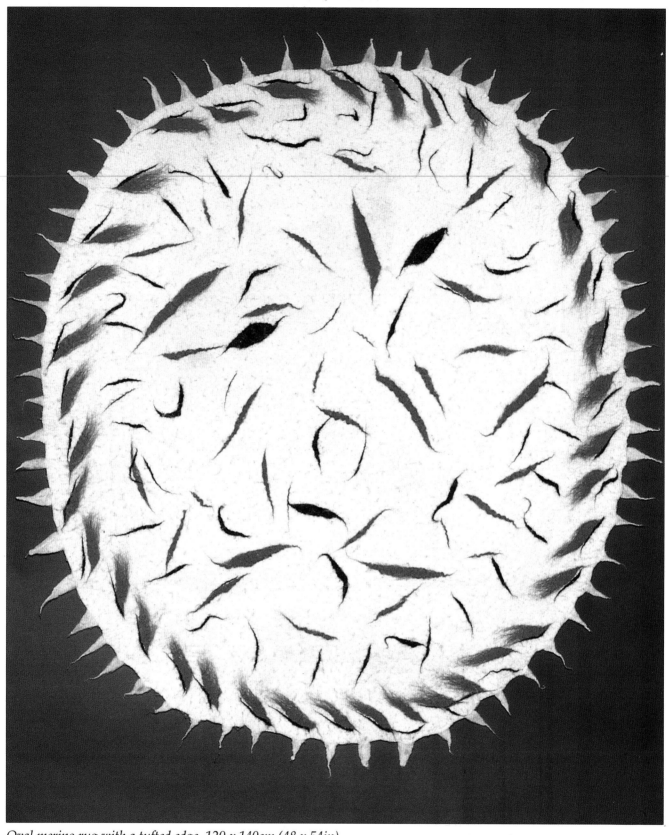

Oval merino rug with a tufted edge, 120 x 140cm (48 x 54in).

COLEG LLANDRILLO COLLEGE
LIBRARY RESOURCE CENTRE 075740
CANOLFAN ADNODDAU LLYFRGELL

Close-up of the corner of the laid out wool for the floor rug shown below. The ten layers of carded wool, with a further pattern layer on top, make quite a thick pile. You need to use lots of soap and water and plenty of hard work to start the felting.

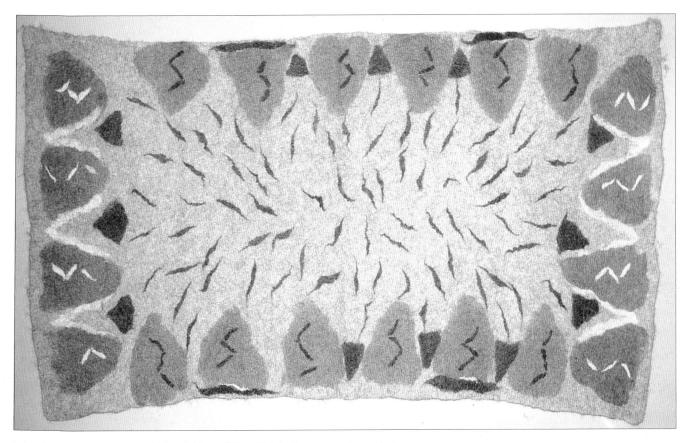

The floor rug measures 180 x 110cm (72 x 42in). It was made entirely from undyed wools with grey Icelandic wool for the base.

Index

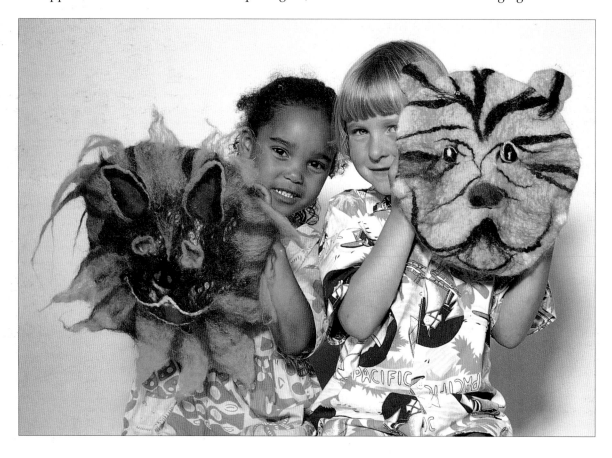

COLEG LLANDRILLO COLLEGE
LIBRARY RESOURCE CENTRE
CANOLFAN ADNODDAU LLYFRGELL